CUBISM & LA SECTION D'OR

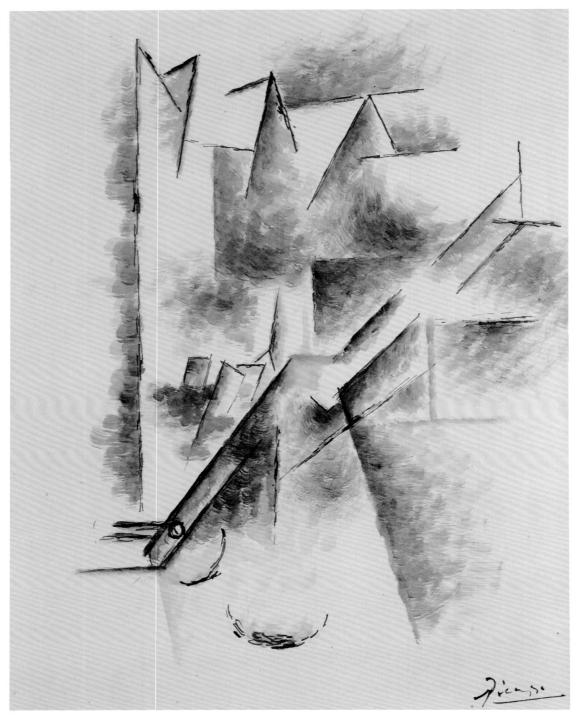

No. 35 PICASSO *L'Eventail,* ink and sepia wash, July-August, 1911

R. Stanley Johnson

CUBISM & LA SECTION D'OR

REFLECTIONS ON THE DEVELOPMENT
OF THE CUBIST EPOCH: 1907-1922

KLEES/GUSTORF PUBLISHERS
Chicago-Düsseldorf
1991

Exhibition Schedule

CUBISM & LA SECTION D'OR: WORKS ON PAPER 1907-1922

The Phillips Collection, Washington D.C.
March 9th-April 28th, 1991

Dallas Museum of Art, Dallas
June 1st-July 28th, 1991

The Minneapolis Institute of Arts, Minneapolis
October 5th-November 17th, 1991

This book catalogues and reproduces the works in the above travelling exhibition. All of these works, including Figures 1-8, are from the R. Stanley and Ursula Johnson Family Collection.

Library of Congress Cataloging Card No. 90-64468
ISBN No. 0-9628903-0-8

A special thanks to Géraldine Anne Johnson for her ideas and suggestions.

Front Jacket

No. 17 Juan Gris (1887-1927)
Tête de Germaine Raynal
Charcoal drawing, 1912

To
Ursula
Géraldine and Grégoire

CONTENTS

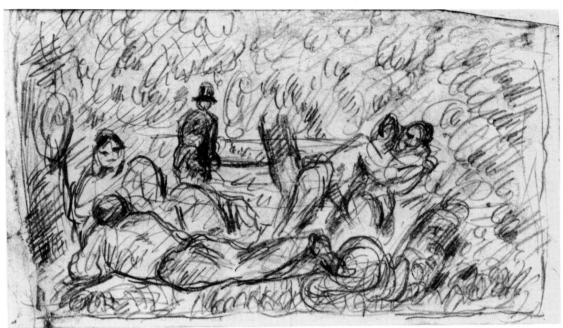

Fig. 1 CEZANNE *Plaisirs de la Campagne* (actual size) Pencil, about 1870

CUBISM & *LA SECTION D'OR* : REFLECTIONS ON THE
DEVELOPMENT OF THE CUBIST EPOCH 1907-1922

 Pablo Picasso and Georges Braque are universally acknowledged as the founders of the Cubist movement. It also generally is accepted that the most important contemporary artistic manifestation of this epoch was the *Section d'Or* (Golden Section) exhibition held in Paris in October, 1912. Therefore, it is surprising to realize that neither Picasso nor Braque participated in this event. Instead, the exhibition included a group of artists with ideas which often were very different from those of Cubism's designated originators. In fact, a careful examination of the concerns of Picasso and Braque as well as the issues raised by a number of the artists at the *Section d'Or* exhibition leads to the conclusion that there were several different concepts of Cubism which co-existed during the Cubist epoch. By exploring the similarities as well as the differences of these approaches to

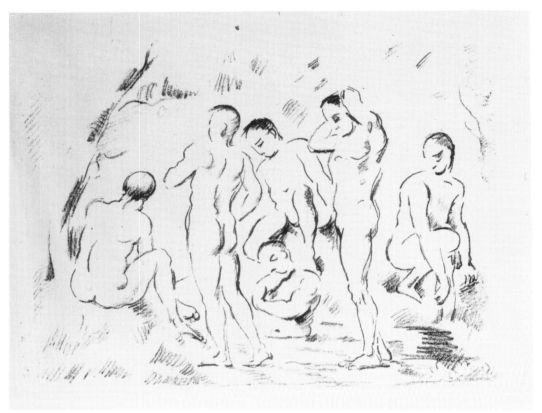

Fig. 2 CEZANNE *Petits Baigneurs* (1st State), lithograph, 1896-1897

Cubism, one gains a more profound understanding of the complexities involved in a movement that has irrevocably changed the history of art in the twentieth century.

<p style="text-align:center">* * *</p>

Pablo Picasso's *Les Demoiselles d'Avignon* of 1907 generally is considered the first Cubist painting. Two major influences lay behind this revolutionary work. One of these was Cézanne who, by going beyond the experiments of the Impressionists, attempted to analyze the act of perception itself. The Impressionists had felt that the only possible subject left to depict was the eye's impression of light. Cézanne, in his art, attempted to establish a new balance between the eye and the mind. To represent his vision of reality, he made use of different perspectives of a given subject. Using these multiple perspectives, Cézanne worked to reduce objects to simple geometric forms, to what he felt to be their essence, rather than merely their exterior appearances. The second key influence in Picasso's great painting was his discovery, probably through Vlaminck and Derain, of the particularities of African sculpture. The subjects of these sculptures often were conceptualized to a degree not seen in Western art since Giotto and other Italian primitives at the beginning of the fourteenth century. Thus, Picasso's search for "reality" attempted to combine the shifting perspectives of Cézanne with the conceptual formulations of African art.

Georges Braque met Picasso late in 1907 and became the first convert to Picasso's new vision of art. By 1909, other artists exploring these and related concepts included Fernand Léger, Robert Delaunay, Jean Metzinger, Albert Gleizes, Marcel Duchamp and Jacques Villon. By 1910, the list of important artists involved in the new ideas had expanded to include Roger de La Fresnaye, Marcoussis and Juan Gris.

The first Cubist exhibit was of Braque's paintings in the Galerie Kahnweiler in Paris in November of 1907. Already in these early works, Braque showed his concern for what would become the Cubist dialectic between the reality of objects in space and the reality of the flat surface of the painting itself. The catalogue introduction for this exhibit was by Guillaume Apollinaire who wrote that Braque ". . . no longer owed anything to his surroundings. His spirit has deliberately challenged the twilight of reality . . . each one of his pictures is a monument to an effort which no one before him had yet attempted."[1] In a review of this exhibit in 1908, Louis Vauxcelles noted that Braque had been emboldened by "the bewildering example of Picasso and Derain" as well as by "the style

[1]Guillaume Apollinaire, *Chroniques d'art. 1902-1918*, (Paris, 1960), pp. 74-77.

No. 31 PICASSO *Étude de Quatre Nus*, black crayon, (study for *Les Demoiselles d' Avignon)*, late 1906-early 1907

of Cézanne" and "the static art of the Egyptians." Vauxelles went on to state that Braque "... reduces everything, places and figures and houses to geometrical schemas, to cubes."[2] This review appears to be the first reference to "cubes" and, other theories notwithstanding, would thus be the origin of the term "Cubism."

<center>* * *</center>

Between 1907 and 1911, Cubism in France gradually reached out beyond Braque and Picasso. Many other artists associated themselves with or were influenced by the new concepts. The differences among these artists, however, were considerable. As a group, they had little in common aside from a general rejection of what they viewed as the apparent lack of "true" reality in the preceding Impressionist movement. In spite of their great differences, these artists were all categorized as "Cubists" and the public became aware of their existence under that name.

It was under these circumstances that the first two major "Cubist" group exhibits took place in Paris within the frameworks of the *Salon des Indépendants* in April-June of 1911 and the *Salon d'Automne* in October-November of that same year. Neither Picasso nor Braque participated in either of these exhibitions. Albert Gleizes, in an article published much later in about 1944, described this *Salon des Independants:*

... We took Room 41, Lhote, Ségonzac, La Fresnaye, etc. installed themselves in the rooms that followed on. It was at this moment that we became acquainted ... In Room 41 we—Le Fauconnier, Léger, Delaunay, Metzinger and myself—grouped ourselves, adding Marie Laurencin to our number at the request of Guillaume Apollinaire. [At the exhibit] ... people were packing into our room, shouting, laughing, raging, protesting, giving vent to their feeling in all sorts of ways; there were arguments going on between those who supported our position and those who condemned it ... At five o'clock *L'Intransigeant* appeared with Guillaume Apollinaire's article. He stressed the importance of our demonstration and defended us vehemently. In the papers that had come out that morning, the more timid critics, including Louis Vauxcelles of *Gil Blas,* attacked us with surprising violence ...

[2]*Gil Blas*, November 14, 1908.

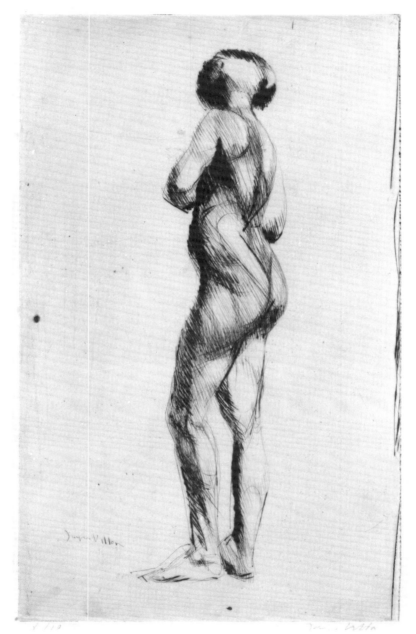

No.49 VILLON *Femme debout, de dos,* etching and drypoint,
1909-1910

Gleizes goes on to describe the parallel Room VIII at the *Salon d'Automne:*

.. Unlike Room 41 of the *Indépendants,* a few months earlier, it had not been arranged by us . . . I suppose Duchamp-Villon [the brother of Marcel Duchamp and Jacques Villon] and La Fresnaye must have been responsible, Duchamp-Villon we did not know and La Fresnaye we had just met at the *Indépendants.* [There were works by] . . . Léger . . . Jacques Villon . . . Metzinger . . . La Fresnaye . . . Le Fauconnier . . . Dunoyer de Ségonzac . . . [and my own] . . . The whole lacked the homogeneity of Room 41. The representatives of orthodox Cubism, Le Fauconnier, Léger, Metzinger and myself were side by side with artists who resembled us only remotely, artists who started from a different point and who were to continue, perhaps forever, to deny that they belonged to Cubism, artists who were therefore fiercely opposed to its inescapable consequences . . . At the same time, here were new and talented artists who found themselves involved in this fusion of orthodoxy and dissidence . . . I refer to Marcel Duchamp and Jacques Villon . . . In spite of its lack of homogeneity, the thing as a whole had a fine irreverent swagger . . .[3]

Two issues are raised by these texts: what was Cubism and who were the "real" Cubists. One answer to these questions emerges from an analysis of art criticism during this period. In addition, it is essential to consider the multi-faceted nature of that most extensive and comprehensive of all contemporary Cubist exhibitions, *La Section d'Or,* which took place the following year in 1912.

<p style="text-align:center">* * *</p>

Some of the most influential early texts on Cubism were those of Maurice Raynal who linked the movement with the principles of the Italian primitives of the early fourteenth century:

. . . the Primitives *thought* the painting more than they saw it . . . When we examine different paintings of Giotto, we are astonished to see either warriors crossing a bridge, when they are bigger than the bridge, or archers on the pinnacle of a tower, when they are larger than it . . . in place of working according to visual dimension, they took into consideration the dimensions of the spirit . . . One must acknowledge that there was more logic in this principle than in the principle of perspective. In place of painting objects as they saw them, they painted them as they thought them, and it is precisely this law that the cubists have taken up again . . .[4]

[3]Edward F. Fry, *Cubism*, (London, 1978 edition), pp. 172-175.

[4]*Ibid*., p. 129. See also Lynn Gamwell, *Cubist Criticism*, (UMI Research Press, 1980), p.2.

<p style="text-align:center">13</p>

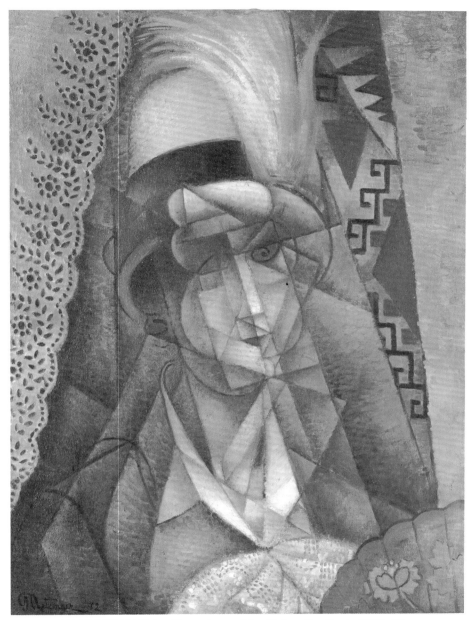

Fig. 3 JEAN METZINGER *La Plume jaune* (The Yellow Feather), 1912. Oil on canvas, 28³/₄ x 21¹/₄ inches. This work was exhibited at *La Section d'Or* exhibit in Paris in 1912.

This idea of painting objects "as they thought them" could have led the Cubist artists in a number of possible directions. One of these could have been a return to a Realism or Impressionism of sorts, perhaps to what André Lhote called "a certain landscape tradition." Another direction could have been towards abstraction. In fact, a number of the major Cubist artists came to the brink of total abstraction only to return to a certain degree of recognizable subject matter. This was the case for Braque in 1910 and Léger in 1913, for example. Those artists, such as Delaunay, who appeared to cross over completely into the realm of total abstraction could no longer be considered "true" Cubists. This was also the case for an artist such as La Fresnaye who gradually returned to a degree of Post-Impressionism with only the exterior signs of Cubism still present. Thus, "true" Cubism at this time was distinguished by a rather narrowly defined balance, actually a tension, between abstraction and realistic representation. From a Cubist point of view, traditional realism and pure abstract art, in their respective ways, each took away the profundity and complexity basic to "reality." In addition, by 1911-1912, a concensus had gradually developed among the more perceptive writers on Cubism such as Allard, Apollinaire and Metzinger that "true" Cubism was marked by what Maurice Raynal in his article of August, 1912, described as the key distinction between conception and vision:

... we never see an object in all its dimensions at the same time ... Now conception gives us a method. Conception makes us perceive the object under all its forms and it even makes us perceive objects that we would not be able to see ... If one admits that the objective of the artist is to come as close as possible to truth through his art, the conceptualist method will lead him there ... If one wants to approach truth, it is necessary to consider only the conceptions of the objects, only those created without the help of the senses, which are the source of inexhaustible error.[5]

This "conceptualist" view of Cubism was only new in that it applied to art. Philosophically, this idea could be traced back to Kant, as summed up by Schopenhauer:

The greatest service that Kant rendered is his distinction between the phenomenon and the thing itself, between that which appears and that which is; and he has shown that between the thing and us, there is always intelligence.

Most of the critics and artists associated with Cubism seemed to agree about at least

[5]Maurice Raynal, "Conception et Vision," *Gil Blas*, August, 1912.

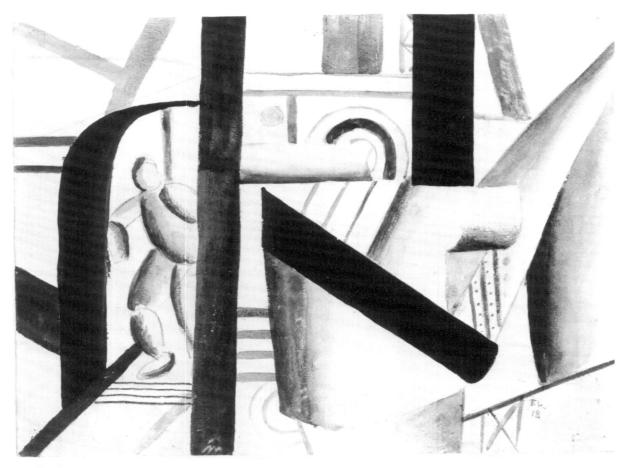

No. 23 LEGER

L'Usine, gouache, 1918

one aspect of this artistic movement. This was that, in contrast to the fleeting appearances created by the Impressionists, Cubist art attempted to represent the underlying and permanent nature of the world. As opposed to what they perceived to be the confusion of the Impressionists and of mid-nineteenth-century Realism, most of these critics and artists believed that "true" reality was the primary objective of Cubism.[6] To express this "reality," a number of pictorial innovations were developed by Picasso and Braque. These included the construction of a painting in terms of a linear framework, the fusion of objects with their surroundings, the freedom of an artist to move around an object resulting in the combination of several views of that object in a single image, and, with the invention of collage, the mixing of real and represented objects in the same picture. It also was felt that "true" Cubism should have no anecdotal, descriptive or decorative objective. In the words of Waldemar George's 1921 text:

> Cubism is an end in itself, a constructive synthesis, an artistic fact, a formal architecture independent of external contingencies, an autonomous language and not a means of representation.[7]

George's view of Cubism as a "constructive synthesis" reflects a good deal of post-World War I literature on Cubism, particularly the writings of Raynal, Kahnweiler and Gris, who also were concerned with the ideas of analysis and synthesis. The first step in these concepts was to analyze the parts of an object which were called "les éléments primordiaux" (Raynal), "geometrischen Formen" (Kahnweiler), or "formes abstraites" (Gris). The second step was to synthesize the parts into a new entity called "un ensemble nouveau" (Raynal), "eine Synthese des Gegenstandes" (Kahnweiler), or "une unité" (Gris).[8] These ideas of analysis and synthesis caused certain art historians to divide Cubism into Analytic Cubism (1907-1912) and Synthetic Cubism (1913-1914). This division became firmly entrenched in American scholarship through Alfred Barr's influential 1936 text, *Cubism and Abstract Art*. As Kahnweiler pointed out, however, Picasso was already "synthesizing" in his *Nu* painted in Cadaques in 1910. Barr's ideas came perhaps from the fact that the year 1912, when collage first entered the language of Cubism, also was the year which marked the first move by artists in Paris towards purely abstract art. Thus, although Barr was certainly correct in seeing 1912 as a turning point for French abstract art, this was not entirely the case for Cubism since that movement's leaders never made the move into pure abstraction.[9]

[6] John Golding, *Cubism: A History and an Analysis 1907-1914*, (London, 1959), p. 27.

[7] Waldemar George, forward to *93. Sturm-Ausstellung*, Der Sturm, (Berlin, January, 1921).

[8] Gamwell, *Cubist Criticism*, pp. 98-99.

[9] *Ibid.*, p. 106.

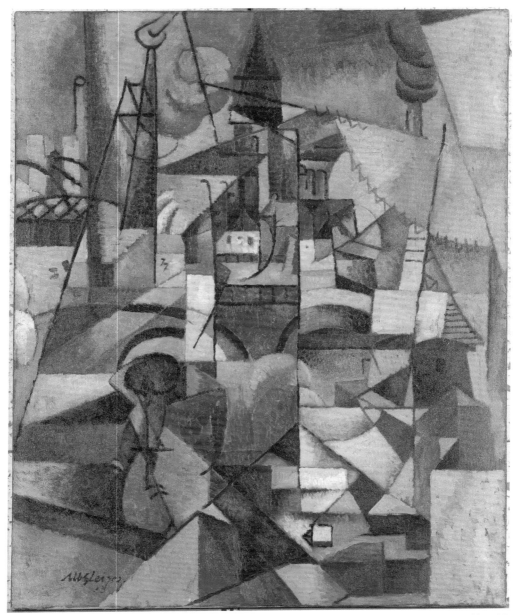

Fig. 4 ALBERT GLEIZES *La Ville et le Fleuve* (City and River), 1913 Oil on canvas, 31$\frac{1}{2}$ x 25 inches This work was included in the exhibit of Duchamp-Villon, Gleizes, Metzinger and Villon at the Sturm Galerie in Berlin in 1914.

* * *

In a rare personal interview with Marius de Zayas in 1923, Picasso expressed some of his own ideas on the meaning of Cubism:

> . . . Nature and art, being two different things, cannot be the same thing. Through art we express our conception of what nature is not . . . The several manners I have used in my art must not be considered as an evolution, or as steps toward an unknown ideal of painting. All I have ever made was made for the present . . . Arts of transition do not exist. In the chronological history of art there are periods which are more positive, more complete than others. This means that there are periods in which there are better artists than in others . . . Many think that Cubism is an art of transition, an experiment which is to bring ulterior results. Those who think that way have not understood it. Cubism is not either a seed or a foetus, but an art dealing primarily with forms, and when a form is realized it is there to live its own life.[10]

In his book *Der Weg zum Kubismus* published in 1920, Daniel-Henry Kahnweiler, Picasso's dealer and one of Cubism's most remarkable theorists, emphasized rather different aspects of Cubism:

> In accordance with its special role as both constructive and representational art, Cubism brings the forms of the physical world as close as possible to their underlying basic forms [*Urformen*]. Making use of these basic forms, upon which all visual and tactile perception is based, Cubism provides the clearest presentation and foundation for all forms. The unconscious effort that we have to make with every object in the physical world before we can know [*erkennen*] its form is diminished by Cubist painting which places before our eyes the relation between those objects and the basic forms. Like a skeletal frame, these forms are the basis of the represented object in the final work of art. These [skeletal] forms then are no longer seen [*gesehen*] but are the basis for the [newly created] seen [*gesehenen*] forms.[11]

In spite of their close relationship, Kahnweiler's concept of Cubism is actually very different from Picasso's. Whereas Kahnweiler begins from the abstract concept of the

[10]"Picasso Speaks," *The Arts*, (New York, May, 1923), pp. 315-326.

[11]Daniel Henry [Kahnweiler], *Der Weg zum Kubismus*, (Munich, 1920), pp. 40-41.

"skeletal frame," Picasso begins by focusing on the object itself. Kahnweiler's "skeletal frame" appears to correspond to the "perfect" triangles and rectangles of the *Section d'Or* (or Golden Section) which were so important in much of the art of Juan Gris and Jacques Villon in particular.

This fundamental difference between Picasso and his dealer, Kahnweiler, leads us back to the question of who the "true" Cubists really were. Some art historians, such as Douglas Cooper, have felt that only four artists should be considered as the "true" Cubists, namely, Picasso, Braque, Léger and Gris. This specific grouping of artists must, however, be considered somewhat more critically. Picasso and Braque historically have been linked together as the originators of the movement despite the great differences between them. Picasso's work is more expressionistic and violent whereas Braque's art seems more calm and reasoned. Picasso appears to have been essentially concerned with the object in itself and the relationship among objects while Braque was more concerned with the space which seperates objects and thus in presenting a smoother, more integrated total image. However, both artists are united in their primary concern with focusing on actual objects in space.

The choice of Léger as one of the "true" Cubists is rather strange. In the years 1909-1912, he did employ certain pictorial elements in common with Picasso and Braque. Very differently from these artists, however, Léger respected the closed contours of the objects he depicted and, in his paintings, made use of visual effects taken directly from nature. In 1913, by moving into total abstraction, Léger broke off completely with the basic principles of Picasso and Braque. In the following years, Léger's interests turned to the life of the modern city. Because of his emphasis on the choice of subject matter, his art then had little to do with Picasso's description of Cubism as "Art dealing primarily with forms." Perhaps the real reason why certain art historians have included Léger with the "true" Cubists was that he was one of the few early twentieth-century artists whose works were of a similar quality and force as those of Picasso and Braque.

It is perhaps for a similar reason that Juan Gris has been included among the four "true" Cubists. Gris was considered the purest Cubist and the one who carried the movement to its highest level. However, Gris gradually moved to a working method which began with total abstraction and ended up with a degree of representation. Gris' process of creating works of art was therefore essentially different from the methods used by Picasso and Braque. Instead of basing a work of art on the multi-faceted appearances of given objects, Gris often initiated his works with a scientifically and abstractly conceived figuration based on the use of the *Section d'Or* (the Golden

Section), a formula which was closely related to Kahnweiler's more general concept of the "skeletal frame." The difference between Picasso and Braque's approaches and that of Gris places the latter in a category apart from the "true" Cubists whose primary concern remained real objects in space. It is not at all surprising, therefore, that Gris, unlike Picasso or Braque, participated in the *Section d'Or* exhibition. In reply to a questionnaire of 1925, Juan Gris stated:

> Cubism? Though I never consciously and after mature reflection became a Cubist, by dint of working along certain lines, I have been classed as such. I have never thought about its causes and its character like someone outside the movement who has meditated on it before adopting it.[12]

Like Gris, Jacques Villon not only participated in the *Section d'Or* exhibition but also often used the mathematical principles of the Golden Section itself.[13] From 1907 to 1911, his art, particularly his etchings and drypoints, had in many ways paralleled some of Picasso and Braque's early Cubist efforts though Villon at this point had never seen any of their works. In 1912, however, Villon, along with Gris, discovered a great affinity for the concept of the Golden Section as described in Leonardo da Vinci's *Trattato della*

[12]"Chez les cubistes," *Bulletin de la vie artistique*, Paris, January 1, 1925, pp. 15-17. See also Fry, *Cubism*, pp. 169-170.

[13]The Golden Section is based on a special ratio in which the small quantity is to the larger quantity as the larger quantity is to the whole. Thus:

$$A / B = B / AB$$

This ratio is uncommensurable and expressable by the non-finite term 1.618. Therefore, the Golden Section can also be described as:

minor / major = major / whole *or* 0.618 / 1,000 = 1.000 / 1,618

Since Egyptian times, this "perfect" ratio has been used in the laying out of buildings as well as in the composition of works of art. For both architects and artists, the key to the Golden Section is the ease with which it can be determined from a right triangle whose height is half its length. On the basis of this division, Golden Section triangles and rectangles can be constructed. See: William A. Camfield, "Juan Gris and the Golden Section," *Art Bulletin*, March 1965, pp. 128-134. Seurat also used this same principle in his *Parade* painting at the Metropolitan Museum of Art in New York. It is sometimes difficult to detect its presence in a work of art. As noted by Camfield, p. 130, the use of the Golden Section by an artist such as George Bellows, for example, might have passed unnoticed without information supplied by the artist himself.

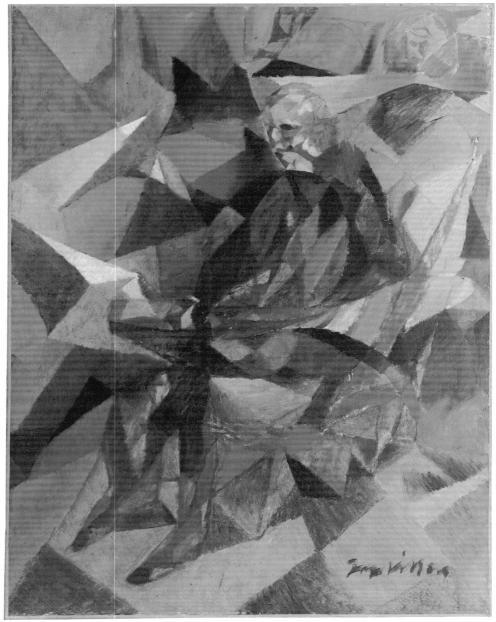

Fig. 5 JACQUES VILLON *Portrait de Monsieur Duchamp*, 1913. Oil on canvas,
 45¹/₂ x 35 inches.

Pittura. This work had been translated into French in 1910 and Villon, as well as Gris, Gleizes and others of a scientific bent in their group were studying this text by 1912.

Of all the artists of the *Section d'Or* exhibition, with the possible exception of Gleizes and Metzinger, it would appear that only Villon and Gris actually made practical use of the concept of the Golden Section. In some of his works of art, however, Gris, after establishing his Golden Section groundwork, tended to lapse more rapidly than Villon into a return to subject matter. In other words, Gris seemed more willing to modify his theoretical approaches depending on his choice of subject. For both Gris and Villon, the Golden Section represented more an ideal process than an absolute goal.

<p style="text-align:center">* * *</p>

The *Section d'Or* exhibition which took place at the Galerie de La Boetie in October, 1912, has been considered the high-point of Cubism as a movement. This event was the most important Cubist manifestation since the *Salon des Indépendants* and the *Salon d'Automne* of 1911. In this exhibition, almost 200 works by thirty-two artists were shown. Works by Picasso and Braque as well as two of the original group of Room 41 of the *Salon des Indépendants*, Delaunay and Le Fauconnier, however, were not included.

The idea for the *Section d'Or* exhibition originated in about 1910 during a series of meetings of artists at the Puteaux studio of Jacques Villon who also suggested the title for the show. By 1911, these artists were meeting regularly in Villon's studio or garden every Sunday. They also gathered at Gleizes' studio in Courbevoie on Mondays and sometimes met at the café La Closerie des Lilas in Montparnasse. Besides the mathematically and scientifically-minded trio of the brothers Marcel Duchamp, Raymond Duchamp-Villon and Jacques Villon, the group included Gleizes, Metzinger, Léger, Picabia, Lhote, Kupka, La Fresnaye and Gris. A number of these artists had already exhibited at the *Salon d'Automne* of 1910.

The *Salon d'Automne* of 1910 marked the beginning of much confusion among art critics who were unclear about the exact meaning they wished to assign to the term "Cubism." Part of this confusion was caused by a lack of distinction between Cubism as an artistic style and Cubism as an aesthetic theory. In an article which appeared in *L'Intransigeant* on the opening of this *Salon* on October 1, 1910, Apollinaire attacked particularly Metzinger's exhibited paintings for "trying out all the various contemporary

TOUS LES ARTS

COLLECTION
PUBLIÉE SOUS LA DIRECTION DE
M. GUILLAUME APOLLINAIRE

GUILLAUME APOLLINAIRE

[Méditations Esthétiques]

Les Peintres Cubistes

PREMIÈRE SÉRIE

Pablo PICASSO — Georges BRAQUE — Jean METZINGER
Albert GLEIZES — Juan GRIS — Mlle Marie LAURENCIN
Fernand LÉGER — Francis PICABIA — Marcel DUCHAMP
DUCHAMP-VILLON, etc.

OUVRAGE ACCOMPAGNÉ DE 46 PORTRAITS ET REPRODUCTIONS HORS TEXTE

PARIS
EUGÈNE FIGUIÈRE ET Cie, ÉDITEURS
7, RUE CORNEILLE, 7
MCMXIII
Tous droits réservés pour tous pays y compris la Suède, la Norvège et la Russie.

65. APOLLINAIRE *Les Peintres Cubistes* (original edition), 1913

ideas" and, indirectly, for having copied the Cubism of Picasso.[14] In another article a few days later, Apollinaire summed up the works of the *Salon d'Automne* artists as a "bizarre manifestation of cubism."[15] On the other hand, by the time of the 1911 *Salon d'Automne,* Apollinaire was supporting this same group which he had rejected the year before. However, in 1911 he did not call any of these artists "Cubists" except for Metzinger whom he described as "the only practitioner of what could be correctly called Cubism."[16] Later on in 1911 in a preface to a catalogue of an exhibition at the Modern Museum of Brussels, Apollinaire at last reluctantly came around to stating that these artists, as a group, "accepted the name Cubist which has been given to them."[17]Apollinaire, in the same review, goes on to state that ". . . Cubism is not a system and the differences which characterize not only the talent but also the manner of these artists is a manifest proof." Finally, Apollinaire shows himself to be even more hesitant on these matters by calling the movement a mixture of Fauve and Cubist approaches: "From these two movements . . . there developed a simple, noble, expressive and measured art."[18] Thus, even while accepting the term "Cubist" for the future *Section d'Or* artists, Apollinaire clearly distinguishes their "Cubism" from the earlier one practiced by Picasso and Braque. By late 1911, Apollinaire had become one of the staunchest supporters of the *Section d'Or* "Cubist" group. Thus at the very moment when the *Section d'Or* group was forming as an alternative to the Cubism of Picasso and Braque, Apollinaire, adding to the confusion, was now also calling the *Section d'Or* artists "Cubists."

Apollinaire was not the only writer confused or disturbed by the term "Cubist." The book written by Gleizes and Metzinger which appeared at the precise moment of the opening of the *Section d'Or* exhibition was not entitled *Du Cubisme* but *Du "Cubisme".* Then Maurice Raynal, in his 1912 review of the *Section d'Or* exhibition, stated his problems with the name "Cubism": ". . . the term 'Cubism' is day by day losing its significance, if it ever had any very definite one."[19] Finally, Apollinaire, attempting to avoid this problem in his book of a few months later, decided on the title *Méditations Esthétiques: Les Peintres Nouveaux. (Aesthetic Meditations: The New Artists)* From the proofs of this book, it is clear that it was only under pressure from his publisher that the title was eventually changed to *Méditations Esthétiques: Les Peintres Cubistes,* an apparently more saleable title but not exactly the subject of the book as originally viewed by Apollinaire. Therefore, unlike later art criticism, the theorists and artists of 1912 were very much aware of the existence of two separate movements: the narrowly defined Cubism of Picasso and Braque which focused on objects in space and the much broader variety and range of interests represented by the *Section d'Or* group of artists.

[14]Apollinaire, *Chroniques d'Art. 1902-1918*, pp. 153-158.

[15]*Ibid.*, p. 159.

[16]*Ibid.*, p. 211.

[17]*Ibid.*, pp. 241-242.

[18]*Ibid.*, p. 242.

[19]Fry, *Cubism*, p. 97.

ALBERT GLEIZES & JEAN METZINGER

DU

"CUBISME"

PARIS
EUGÈNE FIGUIÈRE ET Cⁱᵉ, ÉDITEURS
7, RUE CORNEILLE, 7
MCMXII

64. GLEIZES and METZINGER *Du "Cubisme"*
 (original edition), 1912

In most current art historical texts, the *Section d'Or* remains, not the name of a movement, but simply the name of an exhibition which took place in 1912. Thus, instead of two separate movements, Picasso and Braque on the one hand and the *Section d'Or* artists on the other are still all grouped together under the single heading of "Cubists." Part of this confusion can be attributed to the lack of homogeneity of the artists who exhibited at the *Section d'Or* show. Already on October 23, 1912, the critic Olivier Hourcade stated that ". . . there is no Cubist School. It is absurd to think that all the artists of *La Section d'Or* . . . have any common principle except the desire to react against the negligent decadence of Impressionism."[20] A few artists such as Kupka, for example, had turned completely to abstraction by the time of the exhibition in 1912. Gleizes gradually developed a formalized and basically decorative painting style which eventually also veered towards total abstraction. In the cases of Duchamp and Picabia, both of these artists were notable for their basic rejection of any and all ideals of Cubism. In the case of Metzinger, though his earlier works were influenced by Picasso, from about 1914 on he began to take on the ideas of Gris instead. Thus, at different times, Metzinger could be placed either within the orbit of the Cubism of Picasso and Braque or within that of the *Section d'Or* artists.

The *Section d'Or*-inspired art of Juan Gris and Jacques Villon was quite different from the Cubism of Picasso and Braque. For these latter two artists, the choice of subject matter always remained very important. Gris, on the other hand, in a 1923 letter to the German writer Carl Einstein, clearly states the primacy for him of formal interests over subject matter:

> The world from which I take the elements of reality is not visual but imaginative . . . one could affirm that, save rare exceptions, the working method [of other artists] has always been inductive . . . My working method is just the inverse. It is deductive. It is not the painting X which begins to conform with my subject, but the subject X which begins to conform with my painting. . .[21]

The art of Gris and Villon, in separate ways, approached the ideals of the *Section d'Or* more closely than did the works of any other artists at the exhibition itself. Apollinaire acknowledged in particular Villon's attempts to adhere to these ideals by referring to him as the "creator of metallic paintings whose development certainly must have cost the artist super-human efforts . . . His recent etchings seem to be of great originality."[22]- "Super-human efforts" indeed would have been necessary for Villon as well as for Gris in their attempts to create a scientifically and abstractly based art whose objective still was

[20]*Paris Journal*, October 23, 1912.

[21]Gamwell, *Cubist Criticism*, p. 88.

[22]Apollinaire, *Chroniques d'Art, 1902-1918*, pp. 505-507.

"reality" but which was to have been totally conceptual, absolutely non-romantic and also independent of any personal sensitivity.[23] In search of these goals, the art of both Gris and Villon maintained an ever-present tension between abstraction and representation. Thus, like Picasso and Braque, Gris and Villon still often found themselves seeking "an equilibrium between the given order of nature and the invented order of art."[24] These similarities, however, do not provide sufficient reason to place either of these artists directly within that usual history of Cubism which begins with Picasso's *Les Demoiselles d'Avignon* nor to try to judge the art of Gris and Villon within the traditional Cubist dialectic of "analytic" versus "synthetic" modes.

Gris and Villon, using concepts of the *Section d'Or,* created unique and successful alternatives to the accomplishments of Picasso and Braque. Metzinger and Gleizes were influential as theoreticians but, making limited practical use of their theories, were less decisive in their artistic endeavors. Other valid alternatives to the *Section d'Or* and to Picasso and Braque included Léger's highly individualistic post-1914 move towards a contemporary subject matter and Delaunay's far-reaching experiments with total abstraction. The innovations of all of these artists during the fertile period from 1907 to 1922 influenced the following artistic generations. By exploring the various approaches of these artists, usually grouped too readily under the general heading of "Cubists", one can better appreciate their individual accomplishments and contributions to the art of the twentieth century.

R. Stanley Johnson

[23]See Dora Vallier, *Jacques Villon*, (Musée des Beaux-Arts, Rouen, and Grand Palais, Paris, 1975), p. 15.

[24]Robert Rosenblum, *Cubism and Twentieth Century Art*, (New York, 1961), p. 105.

CUBISM & LA SECTION D'OR

A SELECTION OF
WORKS ON PAPER
1907-1922

GEORGES BRAQUE
1882-1963

1. Etude de nu, 1907-1908

Etching
280 x 195 mm; 11 x 7³/₄ inches
Signed and numbered 10/25

References:
1. Engelberts 1
2. Vallier 1

Notes:
1. The date on this work, according to Hofmann (Werner Hofn ann, *Braque Graphische Werke,* Stuttgart-Salzburg-Zurich, 1961), should be based on a similar 1908 drawing in the Douglas Cooper Collection, London. On the other hand, Wallen and Stein *(The Cubist Print,* 1981) give a date of late 1907.
2. This is the earliest Cubist print by either Braque or Picasso. The only earlier Cubist prints would appear to be the 1907 etchings of Jacques Villon (see nos. 45, 46 and 47 of this book). It is important to note that Villon's 1907 works were produced totally independently of Braque and Picasso.
3. Aside from a few trial proofs printed at the time this work was etched by Braque, there was the edition of 25 impressions on Auvergne paper published by Maeght in 1953.

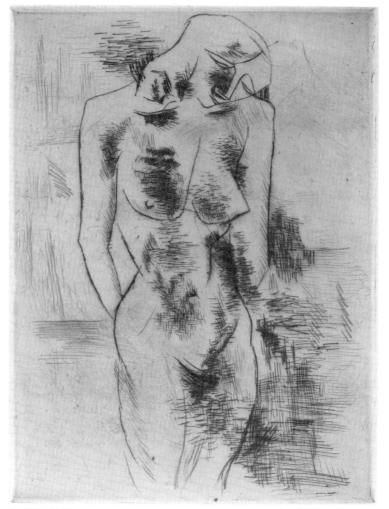

1. BRAQUE Etching, 1907-1908

GEORGES BRAQUE
1882-1963

2. **Paris**, 1910

Etching
200 x 275 mm; 7$\frac{7}{8}$ x 10$\frac{3}{4}$ inches
Signed and numbered 13/30

References:
1. Engelberts 3
2. Vallier 3

Notes:
Aside from a few trial proofs when this work was etched by Braque, there was the edition of
30 impressions on Arches paper printed by Visat and published by Maeght in 1953.

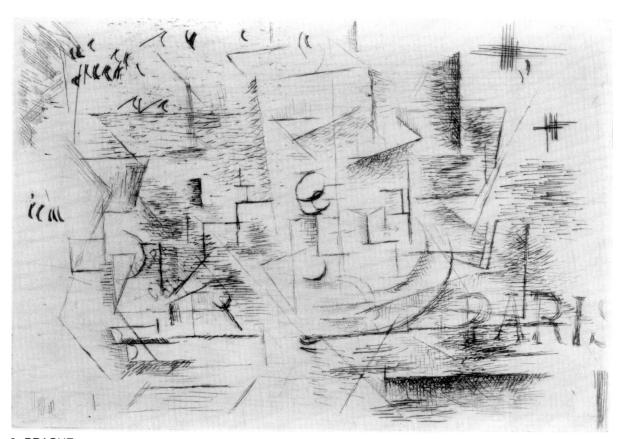

2. BRAQUE Etching, 1910

GEORGES BRAQUE
1882-1963

3. **Job**, 1911

Etching with drypoint
145 x 200 mm.; 5^3/$_4$ x 7^7/$_8$ inches
Signed, numbered "17" in far lower left corner

References:
1. Engelberts 4
2. Vallier 5

Notes:
Along with *Fox*, also of 1911, this was one of the two Cubist prints by Braque, printed by Delâtre and published by Kahnweiler in 1912 in an edition of 100.

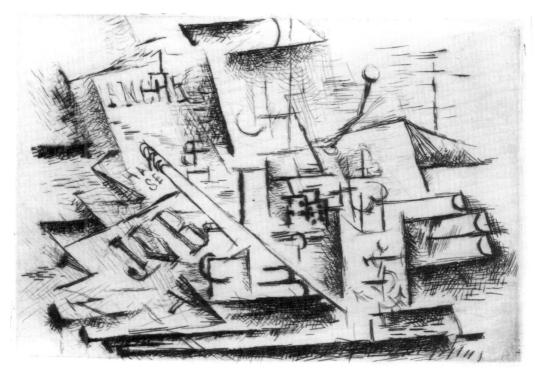

3. BRAQUE

Etching with drypoint, 1911

GEORGES BRAQUE
1882-1963

4. Fox, 1911

Etching
545 x 375 mm; 22$^5/_8$ x 14$^3/_4$ inches
Signed

References:
1. Engelberts 5
2. Vallier 6

Notes:
Along with *Job*, also of 1911, this was one of the two Cubist prints by Braque printed by Delâtre and published by Kahnweiler in 1912 in an edition of 100. All of Braque's other Cubist period prints were not published until the 1950's.

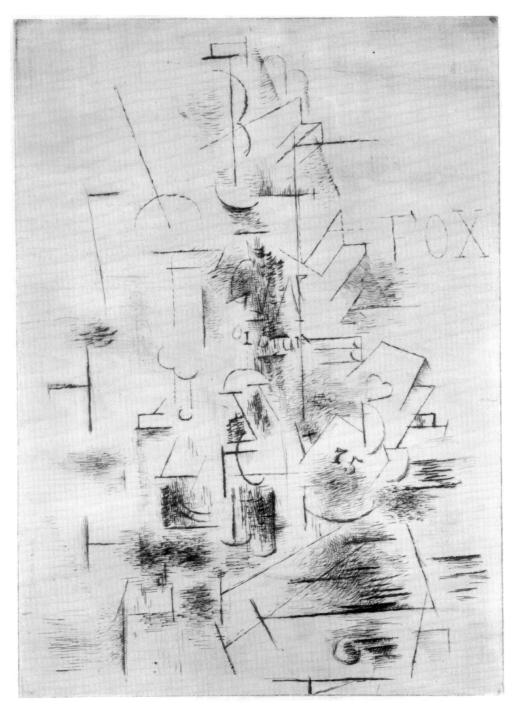

4. BRAQUE Etching, 1911

GEORGES BRAQUE
1882-1963

5. Nature morte I, 1911

Etching
350 x 215 mm.; 13$^{3}/_{4}$ x 8$^{1}/_{2}$ inches
Signed and numbered

References:
1. Engelberts 8
2. Vallier 8

Notes:
Executed by Braque in 1911, this work was published by Maeght in 1950 in an edition of fifty signed and numbered impressions plus ten impressions which were signed and annotated "H.C." (hors commerce).

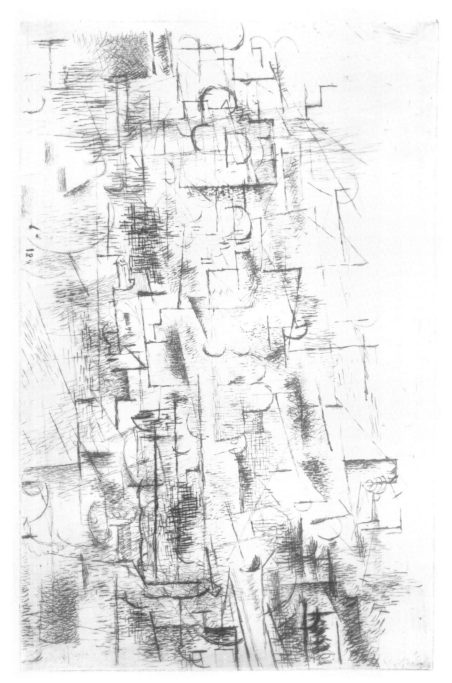

5. BRAQUE Etching, 1911

GEORGES BRAQUE
1882-1963

6. Pale Ale, 1911

Etching
460 x 330 mm.; 18 x 13 inches
Signed and annotated "H.C." (hors commerce).

References:
1. Engelberts 7
2. Vallier 9

Notes:
Aside from a few trial proofs when this work was etched by Braque, there was an edition of 50 impressions plus several "hors commerce" (including this one) on Arches paper printed by Visat and published by Maeght in 1954.

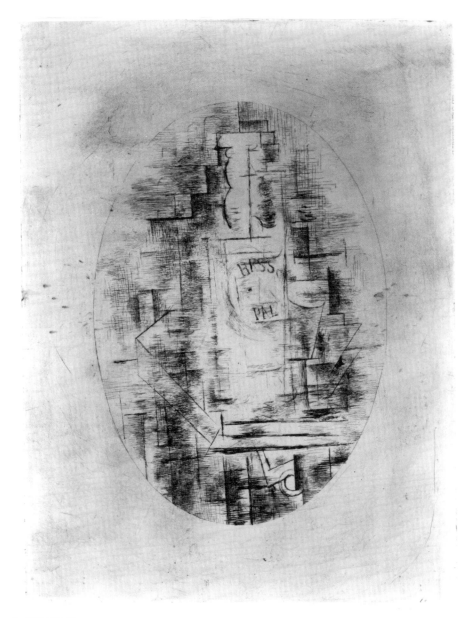

6. BRAQUE Etching, 1911

ROBERT DELAUNAY
1885-1941

7. Saint-Severin (1909)

Lithograph in black and tan executed in 1923-1925
567 x 420 mm.; 22³/₈ x 16⁵/₈ inches
Signed, annotated "St.-Severin", and dedicated: "M. Zamoran avec toute ma sympathie"

Reference:
Loyer and Perussaux, no. 2.

Notes:
There are actually two *Saint-Severin* lithographs executed by Delaunay. Both of these are very rare. The first of these (this one) is dated in the stone "Saint-Severin 1909" and 567 x 420 mm. in size and the second is dated "Saint-Severin 1907" and 572 x 439 mm. in size. There are major differences between these two versions, the most obvious being in the central-left piller. The second *Saint-Severin*, executed around 1926-1928 had been for a book, to have been published by Les Editions Spes, which never appeared.

7. DELAUNAY Lithograph, 1909 (executed in 1923-1925)

ROBERT DELAUNAY
1885-1941

8. **La Tour**, 1910

Transfer lithograph after a painting of 1910, but executed in about 1925.
616 x 451 mm.; 24$^{1}/_{4}$ x 17$^{3}/_{4}$ inches
Signed "R. Delaunay", annotated "épreuve d'artiste" and also annotated "époque destructive".

Reference:
Loyer and Perussaux, no. 3.

Notes:
An edition of 60 is indicated.

8. DELAUNAY Lithograph, 1910 (executed about 1925)

ROBERT DELAUNAY
1885-1941

9. La Tour Eiffel

Lithograph
177 x 177 mm.; 7 x 7 inches
Signed

Notes:
1. One of the 25 "hors commerce" edition on Arches paper. This was an illustration for Joseph Delteil's *Allo! Paris!,* Editions Quatre Chemins, Paris, 1926. See page 89 of Donna Stein, *Cubist Prints: Cubist Books*, Franklin Furnace, New York, 1983.
2. This work is quite close to Delaunay's *The Red Tower*, 1911 (Solomon R. Guggenheim Museum, New York). See illustration No. 36 in: Sherry A. Buckberrough, *Robert Delaunay: The Discovery of Simultaneity*, UMI Research Press, Ann Arbor, 1982.

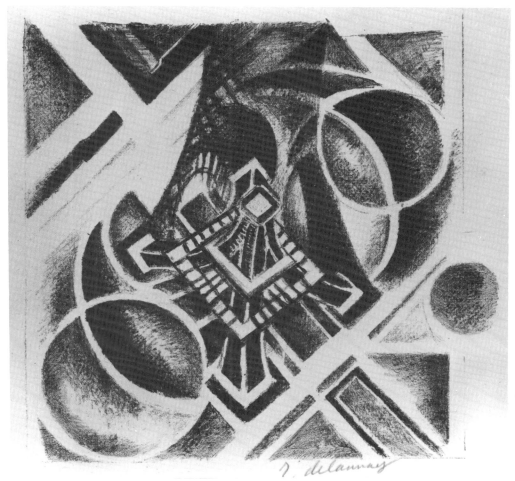

9. DELAUNAY Lithograph

ANDRÉ DERAIN
1880-1954

10. Paysage dans le gout Italien, about 1910-1913

Etching: edition of 50
290 x 358 mm.; 11⁷/₁₆ x 14¹/₁₆ inches
Signed and numbered 36/50

References:
1. Adhemar 49
2. Sawyer, pp. 22-23 (reproduced)

Notes:
Adhemar dates this work about 1913. Sawyer notes, however, that this etching appears to be very close to a Derain watercolor executed at Cagnes in 1910. Derain had spent the summer of 1910 with Picasso and Fernande in the Spanish village of Cadaques before going on to Cagnes. Sawyer feels that this period shows Derain's greatest interest in Cubism and was the basis for this etching.

10. DERAIN Etching, about 1914

ALBERT GLEIZES
1881-1953

11. La Ville de Toul, 1914

Pen and ink drawing
240 x 175 mm.; $9^3/8$ x $6^{13}/16$ inches;
Signed, annotated ("Toul 14") and with a partly legible annotation which appears to be: "A Boiseo-".

Notes:
This drawing is closely related to an etching (Loyer 1) also from 1914 of which the one known impression is in the collection of Mrs. Abraham Melamed (No. 65 and reproduced on page 145 of: Wallen and Stein). It also appears closely related to another pen and ink drawing from 1914, *Etude pour la Ville,* from the collection of Mr. and Mrs. Samuel J. Zacks (No. 59 of: *Albert Gleizes* by Daniel Robbins: Solomon R. Guggenheim Museum, New York; Musée National d'Art Moderne, Paris; and Museum am Ostwall, Dortmund, 1964). This drawing in addition is related to a drawing, *La Ville et le Fleuve*, 1913, belonging to The Solomon R. Guggenheim Museum, New York and no. 46 and illustrated as fig. 3 of the above-mentioned *Gleizes* catalogue. This latter drawing was a direct study for an apparently now lost larger painting, *La Ville et le Fleuve*, 1913 ($86^1/2$ x $73^1/2$ inches), as well as a smaller painting, *La Ville et le Fleuve*, 1913 ($31^1/2$ x $24^3/4$ inches), once in the Graf Collection in Stuttgart, and which, according to Daniel Robbins on page 52 of the Guggenheim catalog, "unfortunately has also disappeared". This latter painting in fact has not "disappeared" but is illustrated in this catalogue as fig. 4 on page 18.

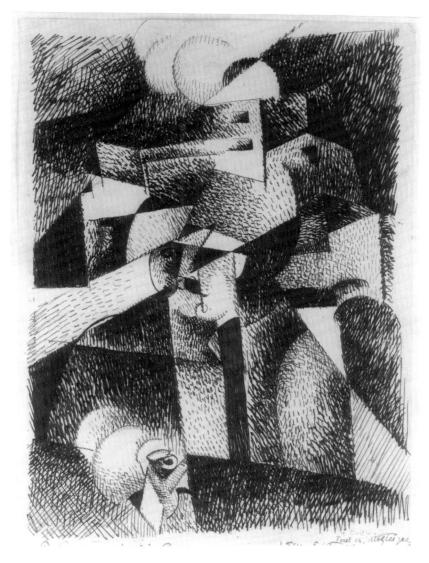

11. GLEIZES Pen and ink drawing, 1914

ALBERT GLEIZES
1881-1953

12. Sur une Ecuyère de cirque, 1914

Etching
242 x 190 mm.; 9^9/$_{16}$ x 7^1/$_2$ inches
Signed and dedicated to Jean Cocteau ("à Jean Cocteau très affecteusement")

Reference:
Loyer No. 2.

Exhibited:
The Cubist Print, Wallen and Stein, 1981, No. 118 and reproduced on page 181.

Notes:
Loyer indicates only one known proof of this etching, that one in a private collection and annotated "essai". This impression therefore appears to be the only other known proof of this work. Loyer also points out a related drawing which had been in a travelling retrospective exhibition, *Albert Gleizes,* in 1964-1965.

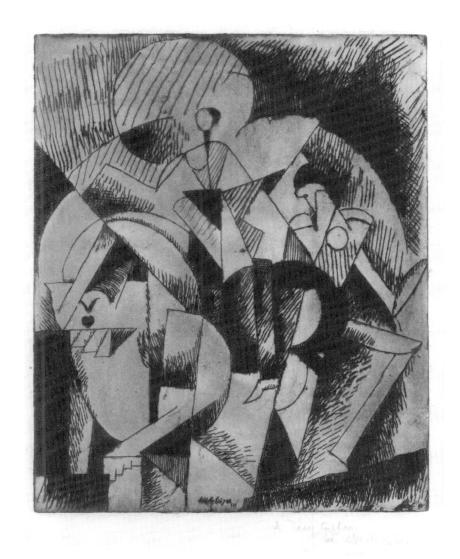

12. GLEIZES Etching, 1914

ALBERT GLEIZES
1881-1953

13. Instruments de musique, about 1915

Charcoal with colored pastels
360 x 270 mm.; 13^3/$_4$ x 10^1/$_2$ inches
Signed with initials, lower right

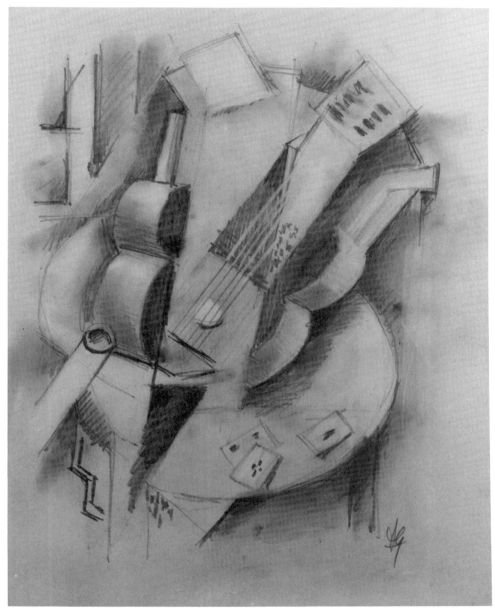

13. GLEIZES Charcoal with colored pastels, about 1915

ALBERT GLEIZES
1881-1953

14. **Motocycliste**, about 1915

 Charcoal with colored pastels
 360 x 270 mm.; 13³/₄ x 10¹/₂ inches
 Signed, lower right, below with the number "11".

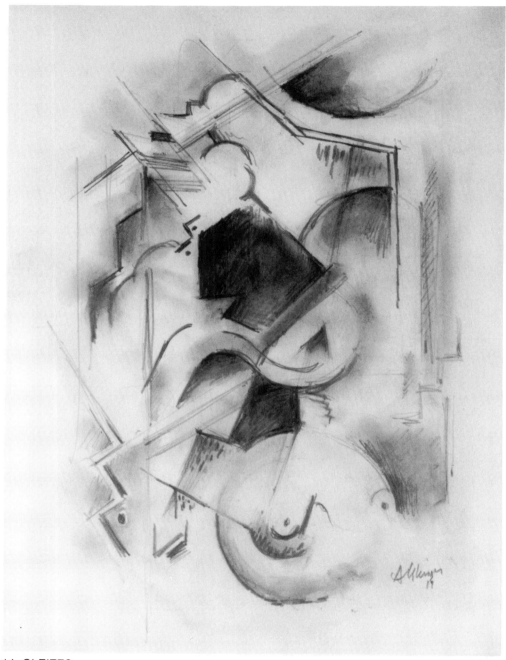

14. GLEIZES Charcoal with colored pastels, about 1915

JUAN GRIS
1887-1927

15. La Rue Ravignan, about 1911

Charcoal drawing with white chalk
480 x 310 mm.; 18⁷/₈ x 12¹/₄ inches

Provenance:
1. From the artist (until 1927)
2. Madame Josette Gris (wife of the artist)
3. Gonzalez Gris (until 1965)
4. Galerie Louise Leiris, Paris

Notes:
1. Picasso arrived in 1904 at the Bateau-Lavoir at 13 rue Ravignan in Montmartre. He lived there until 1909 but kept the apartment as a studio until 1912. Gris arrived at the Bateau-Lavoir in 1906 and stayed there until 1922.
2. See: Jeanine Warnod *Le Bateau-Lavoir,* Paris, 1975, page 142, for another drawing of this period: *La Place Ravignan.*

15. GRIS Charcoal with white chalk, about 1911

JUAN GRIS
1887-1927

16. La Guitare, 1912

Charcoal drawing
316 x 480 mm.; 12$^1/_2$ x 18$^7/_8$ inches

Provenance:
1. From the artist (until 1927)
2. Madame Josette Gris (wife of artist)
3. Gonzalez Gris (son of artist)
4. Galerie Louise Leiris (1965)

Exhibited:
1. *Juan Gris: Dessins et Gouaches 1910-1927,* Galerie Louise Leiris, Paris, 1965: cat. no. 12
2. *Juan Gris*, Museum am Ostwall (Dortmund) and Walraf-Richartz Museum (Cologne), 1955-1956.
3. *Section d'Or,* The Museum of Modern Art, New York, 1967, (ref. no. 67-1323).

16. GRIS Charcoal drawing, 1912

JUAN GRIS
1887-1927

17. Tête de Germaine Raynal, 1912

Charcoal drawing
480 x 317 mm.; 18⁷/₈ x 12¹/₂ inches

Provenance:
1. From the artist (until 1927)
2. Madame Josette Gris
3. Gonzalez Gris (until 1965)
4. Galerie Louise Leiris (1965)

Reference:
Juan Gris by Daniel-Henry Kahnweiler, Paris, 1946: illustrated on page 228.

Exhibited:
1. *Juan Gris Dessins*, Galerie Louise Leiris, Paris, 1965: no. 14 and illustrated on page 228.
2. *The Heroic Years: Paris 1908-1914*, Museum of Fine Arts, Houston.
3. *Section d'Or*, The Museum of Modern Art, New York, 1967: ref: 67-1324 where it was incorrectly catalogued as Portrait of Berthe Lipschitz.
4. *Juan Gris*, Madrid, 1985: no. 120 and illustrated on page 332.

Notes:
1. Germaine Raynal was the wife of Maurice Raynal, one of the most influential critics and writers on art during the Cubist epoch. In 1912, in an article published in August in *Gil Blas*, Raynal formulated the key distinction in Cubism between conception and vision:

> . . . we never see an object in all its dimensions at the same time . . . Now conception gives us a method. Conception makes us perceive the object under all its forms and it even makes us perceive objects that we would not be able to see . . . If one admits that the objective of the artist is to come as close as possible to truth through his art, the conceptualist method will lead him there . . . If one wants to approach truth, it is necessary to consider only the conceptions of the objects, only those created without the help of the senses, which are the source of inexhaustible error.
>
> Maurice Raynal, "Conception et Vision," *Gil Blas,* August, 1912.

2. This work is a particularly striking example of Gris' practical use of the Golden Section.

17. GRIS Charcoal drawing, 1912

ROGER DE LA FRESNAYE
1885-1925

18. Le Cuirassier, 1910-1911

Charcoal drawing
515 x 500 mm.; 20^{1}/$_{4}$ x 19^{3}/$_{4}$ inches
Signed and dated "1910-1911", lower right

Notes:
This very important charcoal drawing appears to be the most complete study for La Fresnaye's painting *Le Cuirassier*, 1910-1911 (180 x 180 cm.), at the Musée National d'Art Moderne in Paris (Seligman No. 110). Both the drawing and the painting are closely related to Gericault's *Cuirassier Blessé* in the Louvre. Seligman notes in the La Fresnaye painting (as in the case of this drawing which Seligman did not know) that ". . . conforming to the Cubist tendancy to anonymity, the face of the horse-holder is half hidden and those of the soldiers are blank."

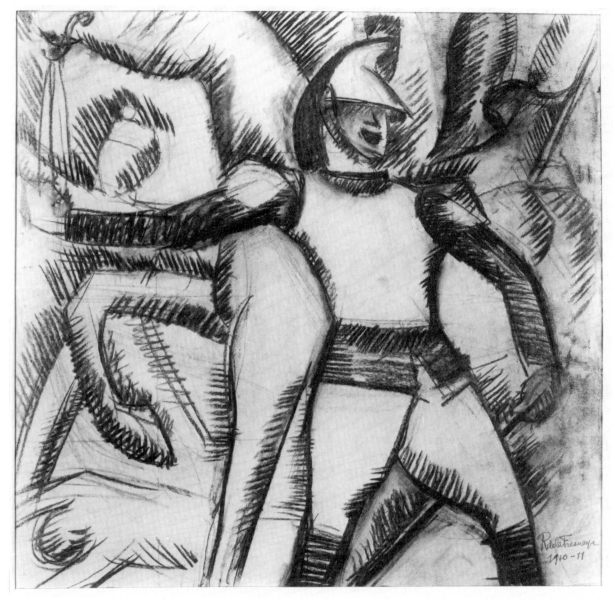

18. LA FRESNAYE

Charcoal drawing, 1910-1911

ROGER DE LA FRESNAYE
1885-1925

19. L'Artillerie, 1911

Woodcut
148 x 191 mm.; 6 x 7^1/$_2$ inches
Signed and dedicated: "A René Jean très amicalement"

Notes:
1. A trial proof of this work, with very wide margins. This woodcut was used as an illustration for Paul Claudel's *Tête d'Or*. There are two closely related drawings (Seligman nos. 112 and 437 both dated 1911) as well as two versions of painting of the same subject (Seligman nos. 111 and 113). The two drawings as well as the woodcut have an extra artillery piece to lower left, not present in either of the paintings.
2. René Jean, to whom this impression was personally dedicated, was a writer and critic who, among other books, wrote a monograph on Dunoyer de Ségonzac.

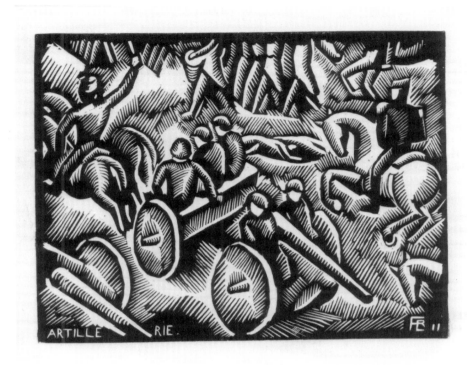

19. LA FRESNAYE Woodcut (trial proof), 1911

ROGER DE LA FRESNAYE
1885-1925

20. Composition au Tambour et à la Trompette, about 1917-1919

Watercolor and brush and india ink
260 x 200 mm.; 10$^{1}/_{4}$ x 7$^{1}/_{8}$ inches

Notes:
1. This work was intended to be an illustration for *Tambour*, an unpublished book by Jean Cocteau.
2. Raymond Radiguet (*Les Oeuvres complètes de Raymond Radiguet*, 1952: page 462) explained the significance of the artistic collaboration between Cocteau and La Fresnaye:

> ". . . Cocteau wrote without thinking in terms of Modernism. There was enough newness in Cocteau so that he could still allow himself to enjoy breathing the scent of a flower. One could say the same thing for the artist Roger de La Fresnaye. The images which will appear in *Tambour* are masterpieces of clearness, grace and artistic balance. . ."

20. LA FRESNAYE Watercolor and brush and india ink, about 1917-1919

ROGER DE LA FRESNAYE
1885-1925

21. Nature Morte, 1914

Transfer lithograph: edition of 25
292 x 381 mm.; 11$^1/_2$ x 15 inches
Signed with initials and numbered "18/25 R F". Signed in stone, "R. de la Fresnaye 1914".

Exhibited:
The Cubist Print, Wallen and Stein, 1981, No. 84 and reproduced on page 157.

R de la Fresnaye 1914

21. LA FRESNAYE Lithograph, 1914

71

FERNAND LEGER
1881-1955

22. **Contrastes de Formes**, 1913

Gouache
370 x 280 mm.; 14^1/$_2$ x 11 inches
Initialed and dated, lower right

Provenance:
Galerie Louise Leiris No. 14831 / 30488 (D.H. Kahnweiler)

Exhibited:
Fernand Léger: Retrospective Exhibition, R.S. Johnson Fine Art, Chicago, 1966: no. 4
and reproduced in color on page 6.

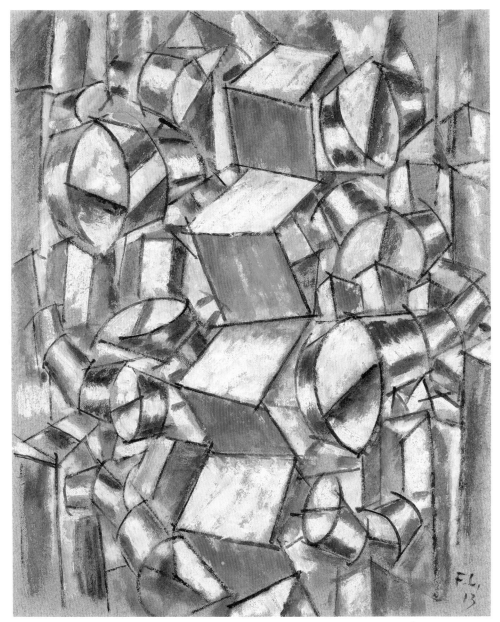

22. LEGER Gouache, 1913

FERNAND LEGER
1881-1955

23. L'Usine, 1918

Gouache
230 x 310 mm; 9^1/$_8$ x 11^3/$_8$ inches
Initialed and dated, lower right

Provenance:
Galerie Louise Leiris (D.H. Kahnweiler)

Exhibited:
1. *Continental Watercolors and Drawings 1880-1965*, R.S. Johnson Fine Art, Chicago, 1965: No. 25.
2. *Fernand Léger: Retrospective Exhibition*, R.S. Johnson Fine Art, Chicago, 1966: No. 11 and reproduced on page 16.

23. LEGER

Gouache, 1918

FERNAND LEGER
1881-1955

24. **Etude pour "la Ville"**, 1919

Gouache
383 x 280 mm.; 15$^{1}/_{16}$ x 11$^{1}/_{16}$ inches
Initialed "F.L.", dated "19" and annotated "étude pour la ville", lower right.

Provenance:
Galerie Louise Leiris No. 017179 / 30812

Notes:
This gouache clearly is a study for the right-hand side of *La Ville (The City)* oil painting, 91 x 117$^{1}/_{2}$ inches, no. 91 and reproduced in color on page 59 of: *A.E. Gallatin Collection*, Philadelphia Museum of Art, 1954.

24. LEGER Gouache, 1919

FERNAND LEGER
1881-1955

25. Composition aux deux Personnages, 1920

Lithograph
287 x 238 mm.; 11$^{1}/_{4}$ x 9$^{3}/_{8}$ inches
Signed, lower right

Reference:
Saphire 2

Exhibited:
The Cubist Print, Wallen and Stein, 1981, No. 75.

Notes:
This lithograph, in an un-numbered edition of 125, was included in the portfolio *Die Schaffenden* no. 4, 1920. *Die Schaffenden* was announced in *Das Kunstblatt* in December, 1920.

25. LEGER Lithograph, 1920

FERNAND LEGER

1881-1955

26. Etude pour le Grand Déjeuner, about 1920

Pencil Drawing
370 x 282 mm.; 14⅝ x 11³/₁₆ inches
Signed with initials, lower right

Provenance:
André Lefèvre, Paris (Hotel Drouot, Quatrième Vente André Lefèvre, Nov. 24, 1967: no. 29).

Notes:
This major pencil drawing is a study related to several paintings including:
1. *Study for the Grand Déjeuner*, 1919-1920, of *Fernand Léger*, R.S. Johnson Fine Art, 1966, No. 13.
2. *Le Grand Déjeuner*, 1921, from the Museum of Modern Art, New York
3. *Le Corsage Rouge*, 1922, of *Fernand Léger*, R.S. Johnson Fine Art, 1966, No. 19.
 (see illustration below).

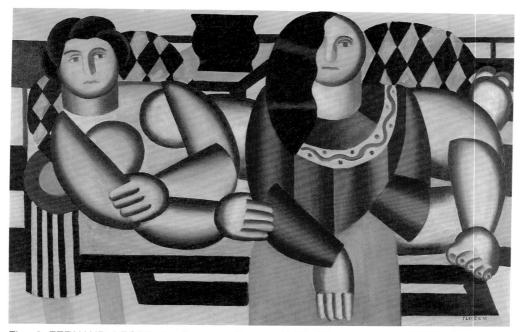

Fig. 6 FERNAND LEGER *Le Corsage Rouge*, 1922. Oil on canvas, 23½X36¼ inches. Formerly Collection Galerie Simon (D.H. Kahnweiler).

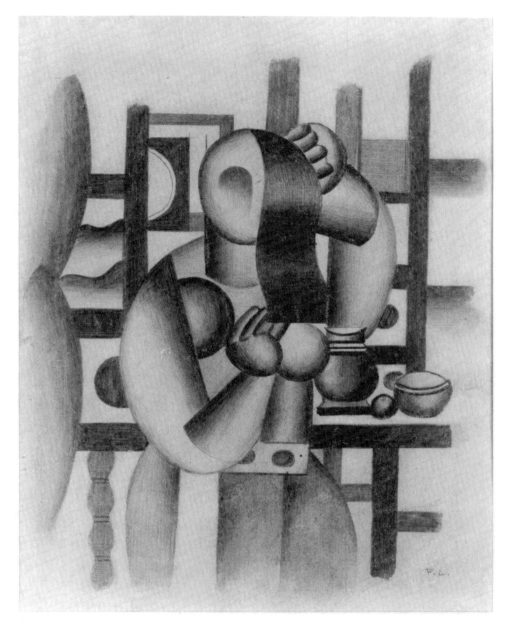

26. LEGER

Pencil drawing, about 1920

FERNAND LEGER
1881-1955

27. **Figures dans un Paysage**, 1921

Pencil drawing
370 x 265 mm.; 14$^5/_8$ x 19$^1/_2$ inches
Initialed and dated, lower right
Verso: A pencil sketch *Figures dans un Paysage*, circa 1919-1920

Exhibited:
European Prints and Drawings 1890-1980, R.S. Johnson Fine Art, Chicago, 1988, No. 29
and reproduced on page 49.

Note:
This exceptional drawing relates to a series of other Léger works from 1920-1922 including
Fishermen, oil on canvas, 1921, *Fernand Léger*, R.S. Johnson Fine Art, Chicago, 1966, No.
17 and illustrated on page 23.

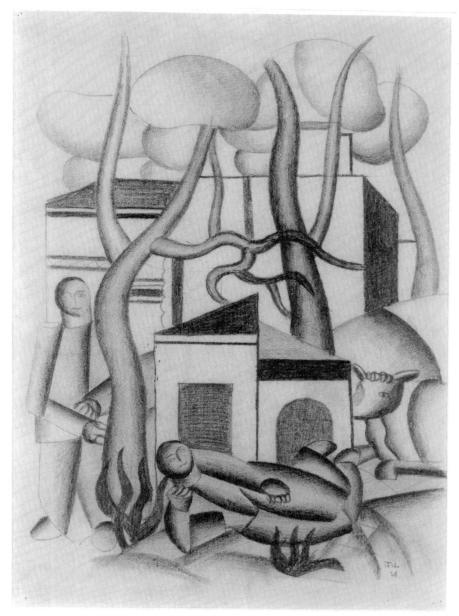

27. LEGER Pencil drawing, 1921

LOUIS MARCOUSSIS
1878-1941

28. Portrait de Guillaume Apollinaire, 1912-1920

Drypoint, etching and aquatint
492 x 278 mm.; 19³/₈ x 19¹⁵/₁₆ inches
Signed "L. Marcoussis" and numbered 11/30

Reference:
Lafranchis G. 32

Notes:
This famous portrait of the poet and critic Guillaume Apollinaire was published in 1920 by Camille Bloch in Paris. The edition appears to have been 30 numbered impressions plus ten others with Roman numbers for a total of 40. This work had been executed by Marcoussis in 1912 and then apparently re-worked in 1918-1920 (with the addition of bandages around Apollinaire's head) before publication in 1920 after the death of Apollinaire.

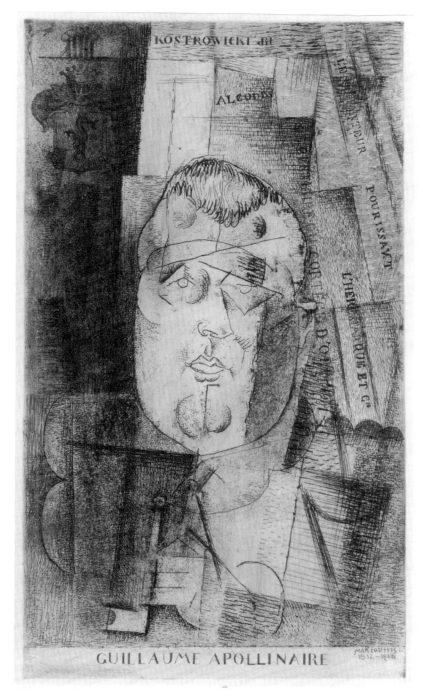

28. MARCOUSSIS Drypoint, etching and aquatint, 1912-1920

JEAN METZINGER
1883-1956

29. Etude pour Le Cycliste, about 1911-1912

Charcoal on paper
345 x 280 mm.; 13^5/$_8$ x 11 inches
Signed, lower right

Provenance:
Neilsen, Copenhagen

Exhibited:
Jean Metzinger in Retrospect, Joann Moser: The University of Iowa Museum of Art, Iowa City; Archer M. Huntington Art Gallery, Austin; The David and Alfred Smart Gallery, The University of Chicago; and the Carnegie Institute, Pittsburgh, 1985-1986, No. 50 and reproduced on page 57.

Notes:
This drawing clearly is a study for *Le Cycliste*, oil with sand and paper collage on canvas (51^3/$_8$ x 38^1/$_4$ inches), Peggy Guggenheim Collection, Venice.

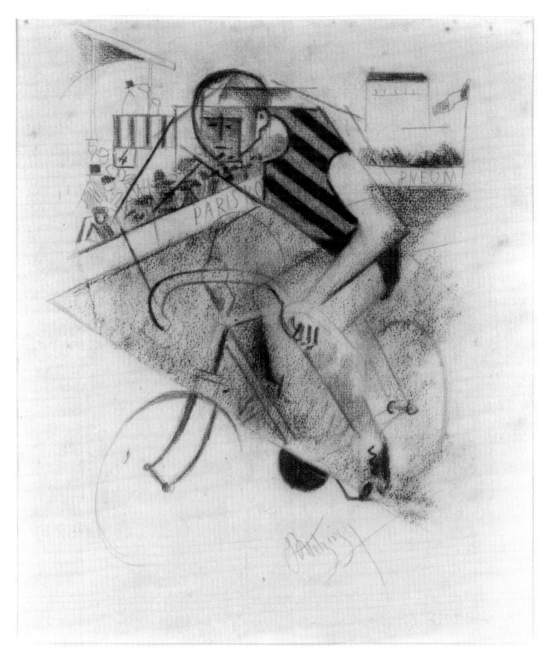

29. METZINGER

Charcoal drawing, about 1911-1912

JEAN METZINGER
1883-1956

30. Femme aux Boucles d'Oreille, about 1919

Charcoal drawing in oval form
465 x 312 mm.; 18^1/$_4$ x 12^1/$_4$ inches
Signed, lower right

Exhibited:
1. *Metzinger: Pre-Cubist and Cubist Works 1900-1930*, R.S. Johnson Fine Art, 1964, reproduced on page 1.
2. *Section d'Or*, The Museum of Modern Art, New York, 1967, ref. no. 67, 1322.

Notes:
Madame Jean Metzinger had dated this drawing 1912 which is the same date indicated in the 1964 Chicago exhibit as well as that at the Museum of Modern Art in New York in 1967. We now have re-dated this work to about 1919. This work in fact corresponds most closely to the oval drawings nos. 71 and 72 as well as the oval paintings nos. 73 and 74 reproduced on pages 66 and 67 of: *Jean Metzinger In Retrospect*, Joann Moser, the University of Iowa Museum of Art, 1985. All four of these latter works are dated quite correctly, in our opinion, to about 1919. This drawing clearly is from the same period.

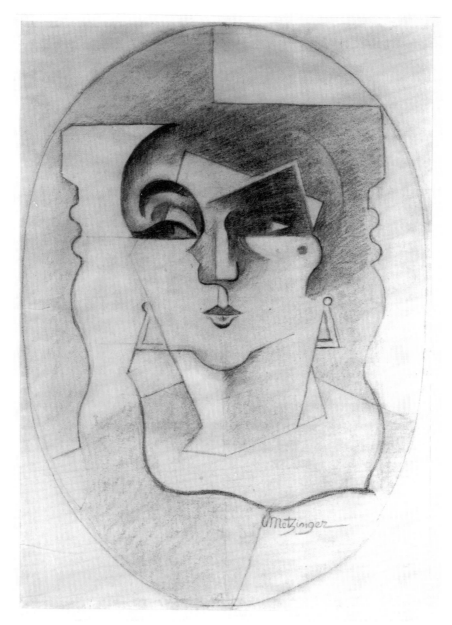

30. METZINGER Charcoal drawing, about 1919

PABLO PICASSO
1881-1973

31. Etude de Quatre Nus, late 1906-early 1907

Black crayon on paper
300 x 200 mm.; 5$^1/_8$ x 7$^3/_4$ inches
Signed, lower left

Provenance:
Heinz Berggruen, Paris

References:
1. Pierre Daix, Georges Bondaille and Joan Rosselet, *Picasso 1900-1906*, Neuchatel, 1966: no. XVI. 20, illustrated p. 325.
2. Christian Zervos, *Pablo Picasso, Supplément aux Années 1903-1906*, vol. 22, Paris, 1970, no. 461, illustrated p. 162.
3. Paris, Musée Picasso, *Les Demoiselles d'Avignon,* 1988, illustrated p. 20.

Notes:
This drawing clearly is a study for *Les Demoiselles d'Avignon* of 1907. Although Zervos dates this drawing as autumn of 1906, we have preferred to assign this work a more general time period of late 1906-early 1907. In this respect, it is to be noted that this drawing is closely related to two major oils of autumn, 1906. In fact, the two standing figures at the left are found in the 1906 *Deux Femmes nues* painting at the Museum of Modern Art in New York. Three of the figures in this drawing are quite close to *Trois Nus* in the Barnes Collection in Merion, Pennsylvania (see: Zervos vol. I, no. 349) Pierre Daix points out that this Barnes Picasso is an immediate study for *Les Demoiselles d'Avignon* of 1907. This latter painting as well as this drawing thus could be dated late 1906-early 1907. In this context, this drawing is of particular interest in that the two nude women on the left are in the same pose as the corresponding figures would be in the *Demoiselles d'Avignon* of 1907.

31. PICASSO Black crayon, late 1906-early 1907

PABLO PICASSO
1881-1973

32. Deux Figures Nues, 1909

Drypoint: edition of 100
130 x 110 mm.; $5^3/_{16}$ x $4^7/_{16}$ inches
Signed

References:
1. Geiser 21/III/6
2. Bloch 17

32. PICASSO Drypoint (actual size), 1909

PABLO PICASSO
1881-1973

33. Nature morte compotier, 1909

Drypoint: edition of 100
130 x 110 mm.; 5$\frac{1}{8}$ x 4$\frac{3}{8}$ inches
Signed

References:
1. Geiser 22/III/b
2. Bloch 18

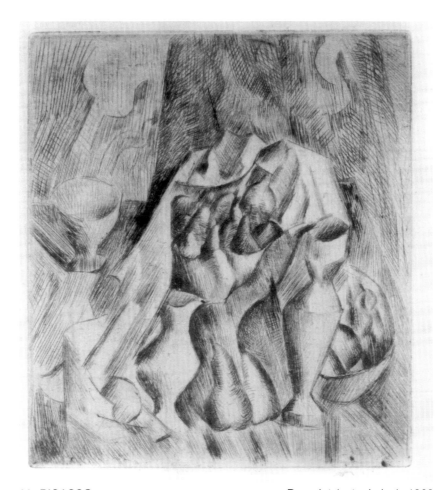

33. PICASSO Drypoint (actual size), 1909

PABLO PICASSO
1881-1973

34. Mademoiselle Léonie dans une Chaise longue, 1910

Etching
198 x 142 mm.; $7^{13}/_{16}$ x $5^{9}/_{16}$ inches

References:
1. Geiser 25/III/b
2. Bloch 21

Notes:
A proof impression aside from the normal impressions used as one of four illustrations for Max Jacob's *Saint Matorel* published in an edition of 104 by Henry Kahnweiler, Paris, 1911.

34. PICASSO Etching (proof impression), 1910

PABLO PICASSO
1881-1973

35. L'Eventail, Summer, 1911

Ink and sepia wash on paper
285 x 222 mm.; 11^{1}/$_{4}$ x 8^{3}/$_{4}$ inches
Signed, lower right

Provenances:
1. J. Leperrier, Paris
2. André Lefèvre, Paris (3rd Sale, Paris, Palais Galliera, November 29, 1966: catalogue no. 45, illustrated)
3. Sale: London, Sotheby & Co., *Impressionist and Modern Paintings, Drawings and Sculpture*, November 29th, 1967: catalogue no. 76, illustrated.
4. Thomas Agnew & Sons, Ltd., London
5. Alan Wilkinson, London and Toronto.

References:
1. André Level, *Picasso*, Paris, 1928, page 33, illustrated.
2. Christian Zervos, *Pablo Picasso, Oeuvres de 1906 à 1912*, Paris, 1942, vol. II, page 133, no. 269, illustrated.
3. Wilhelm Boeck and Jaime Sabartes, *Pablo Picasso*, New York, 1955, page 462, no. 57, illustrated.
4. *L'opera completa di Picasso cubista*, Milano, 1972, page 108, no. 416, illustrated.
5. Pierre Daix and Joan Rosselet, *Picasso: The Cubist Years: 1907 - 1916, A Catalogue Raisonné of the Painting and Related Works*, London, 1979, page 266, no. 406, illustrated. See nos. 410, 411 and 412 for illustrations of related oils.
6. Josep Palau i Fabre, *Picasso en Cataluna*, Barcelona, 1975, no. 229.
7. Josep Palau i Fabre, *Picasso Cubism 1907-1917*, New York, 1990, No. 589, page 214.

Exhibited:
1. Paris, Musée National d'Art Modern, *Paris-Prague 1906-1930*, March 17-April 17, 1964, no. 255.
2. London, Thomas Agnew & Sons, Ltd. *Exhibition of French and English Drawings 19th and 20th Centuries*, 1968: catalogue no. 3.
3. London, the Tate Gallery, *Abstraction: Towards a New Art, Painting 1910-1920*, February 5-April 13, 1980, page 29, no. 2, illustrated.

Notes:
1. This work was executed in the summer of 1911. Picasso had gone to Ceret, a small town in the French Pyrenées, in early July of 1911. There he shared an old villa, the Maison Delcros, with the sculptor Manolo. Braque, Fernande and Max Jacob arrived in Ceret soon thereafter. It was at this time that Picasso painted *Still Life with Fan* for which this wash drawing appears to be a direct study. In the painting, Picasso used lettering (an idea previously introduced by Braque) which further emphasized the Cubist ambiguities of surface and depth. The use of the subject of a fan or of fanlike patterns was found often in Picasso's works of 1909 to 1912. This was because the way in which this subject opened outwards corresponded so well to the articulation of the "new space" which he had in mind. In this phase of tension and austerity, however, Picasso very rarely had recourse to watercolor or wash drawing. Two exceptions are this work, *L'Eventail,* and the watercolor *Sugar Bowl and Fan* of 1910 from the collection of Heinz Berggruen (See pages 36-37 of: *Picasso Drawings* by Jean Leymarie, 1967). Picasso's Ceret period ended when, on August 23, 1911, he read in a newspaper that the *Mona Lisa* had been stolen. He immediately returned to Paris and on September 6, 1911, Picasso and Apollinaire "anonymously" gave back two Iberian heads which also had been taken from the Louvre. Thus, the Ceret period of Picasso and Braque only lasted some six weeks. During these

35. PICASSO Ink and sepia wash, July-August, 1911

few weeks, there was an intense interaction between these two artists. In allowing the objects depicted in their works to be only obliquely suggested beneath a structure of lines and planes, Picasso and Braque brought their Cubism to an almost complete abstraction. This development has been categorized as the moment of "high" or "hermetic" Cubism. The small number of works produced in these weeks that Picasso and Braque spent together at Ceret "like mountaineers roped together" represent one of the most marking periods in the early history of twentieth-century art.

2. Picasso paintings executed at Ceret in the summer of 1911 and related to this wash drawing include *Still Life with Fan (Nature morte à l'Eventail*, also called *L'Indépendant)* of the J.C. Koerfer Collection in Switzerland; the *Clarinet* (National Gallery, Prague); *The Accordeonist* (The Solomon R. Guggenheim Museum, New York); *Man with Pipe* (Kimbell Art Museum, Fort Worth); *Glass, Violin and Fan* (Private Collection, Paris); and *Fan, Pipe and Glass* (Honolulu Academy of Fine Arts).

PABLO PICASSO
1881-1973

36. Tête d'homme, 1912

Etching
130 x 110 mm.; 5^1/$_8$ x 4^5/$_{16}$ inches
Signed

References:
1. Geiser 32/b
2. Bloch 23

Notes:
This etching in an edition of 100 was published in Paris by Henry Kahnweiler in 1912.

36. PICASSO Etching (actual size), 1912

PABLO PICASSO
1881-1973

37. Nature Morte, Bouteille, 1911

Drypoint
500 x 306 mm.; $19^9/_{16}$ x $12^1/_{16}$ inches
Signed

References:
1. Geiser 33/b
2. Bloch 24

Notes:
This work, in an edition of 100, was published in Paris by Henry Kahnweiler in 1912.

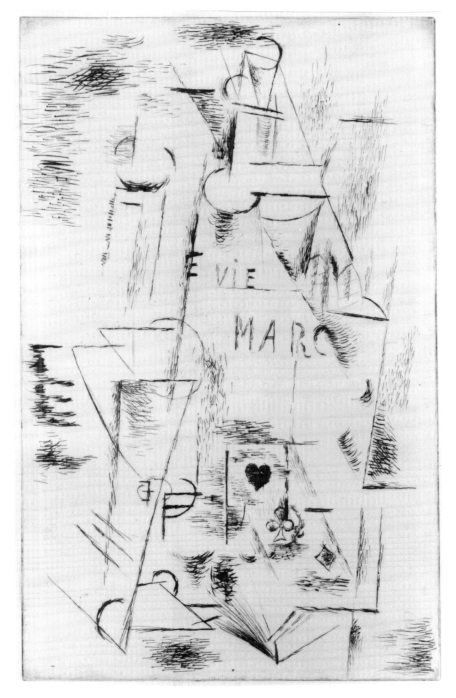

37. PICASSO

Drypoint, 1911

PABLO PICASSO
1881-1973

38. Femme à la Cithare, about 1913-1914

Pencil Drawing
640 x 470 mm.; 25$^{1}/_{8}$ x 18$^{1}/_{2}$ inches
Signed on Verso

Provenances:
1. Galerie Louise Leiris, Paris
2. G. David Thompson, Pittsburgh
3. Galerie Beyeler, Basel
4. Waddington & Tooth Galleries, London
5. Mr. and Mrs. Ahmet Ertegun

References:
1. Christian Zervos, *Pablo Picasso,* vol. 29, *Supplément aux années 1914-1919,* Paris, 1975, p. 64, no. 140, illustrated.
2. Pierre Daix and Joan Rosselet, *Le Cubisme de Picasso, Catalogue raisonné de l'oeuvre peint 1907-1916,* Neuchatel, 1979, p. 137, illustrated.

Exhibited:
1. Zurich, Kunsthaus Zurich, *Collection G. David Thompson 1960-1961*, no. 169. This exhibition travelled to the Kunstmuseum in Düsseldorf, the Gemeentmuseum in The Hague, and the Galleria Civica d'Arte Moderna in Torino.
2. Frankfurt, Frankfurter Kunstverein, *Picasso, 150 Handzeichnungen aus sieben Jahrzehnten*, no. 52, 1965.

Notes:
This Cubist study was executed in 1913, according to Daix and Rosselet, in 1914 according to Galerie Louise Leiris, and in 1915 according to Zervos. We have dated this work about 1913-1914. It clearly is a study for *Femme à la guitare,* oil on canvas, 130.5 x 90 cm, 1914, which was formerly collection of Dr. H.C. Raoul La Roche and since 1952 has been No. 2307 *(Katalog 19/20. Jahrhundert)* in the Kunstmuseum in Basel.

38. PICASSO Pencil drawing, 1913-1914

PABLO PICASSO
1881-1973

39. Femme nue, 1913-1914

Etching and drypoint
156 x 116 mm.; $6^3/_8$ x $4^5/_8$ inches

References:
1. Geiser 35/VI
2. Bloch 25

Notes:
A proof impression aside from the normal impressions used as one of three illustrations for
Max Jacob's *Le Siège de Jérusalem* published in an edition of 104 by Henry Kahnweiler,
Paris, 1914.

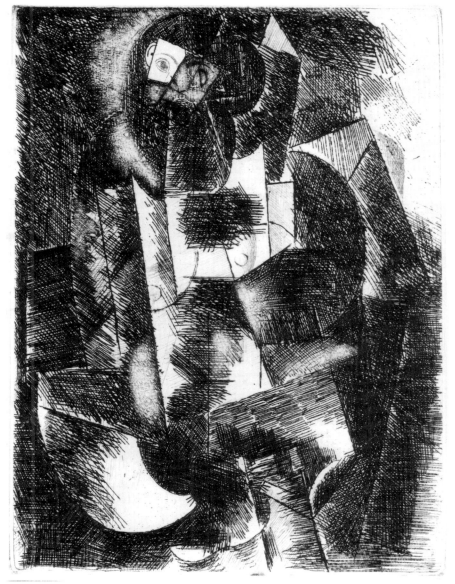

39. PICASSO Etching and drypoint (proof impression), 1913-1914

PABLO PICASSO
1881-1973

40. **Nature morte au Crâne**, 1914

Drypoint
154 x 114 mm.; $6^{1}/_{16}$ x $4^{1}/_{2}$ inches

References:
1. Geiser 36/II/b
2. Bloch 26

Notes:
A proof impression aside from the normal impressions used as one of three illustrations for Max Jacob's *Le Siège de Jérusalem* published in an edition of 104 by Henry Kahnweiler, Paris, 1914.

40. PICASSO Drypoint (proof impression), 1914

PABLO PICASSO
1881-1973

41. Femme, 1914

Drypoint
160 x 109 mm.; 6$^5/_{16}$ x 4$^5/_{16}$ inches

References:
1. Geiser 37/IV/b
2. Bloch 27

Notes:
A proof impression aside from the normal impression used as one of three illustrations for Max Jacob's *Le Siège de Jérusalem* published in an edition of 104 by Henry Kahnweiler, Paris, 1914.

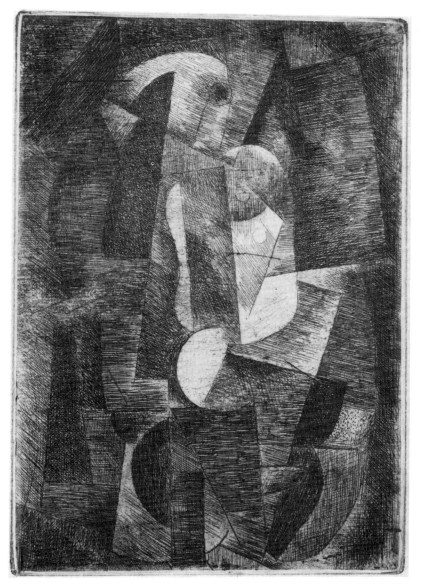

41. PICASSO Drypoint (proof impression), 1914

PABLO PICASSO
1881-1973

42. L'Homme au Chien, 1914

Etching
278 x 218 mm.; $10^{15}/_{16}$ x $8^5/_8$ inches
Signed

References:
1. Geiser 39/III
2. Bloch 28

Notes:
This etching was published later (about 1930) in an edition of 102 proofs.

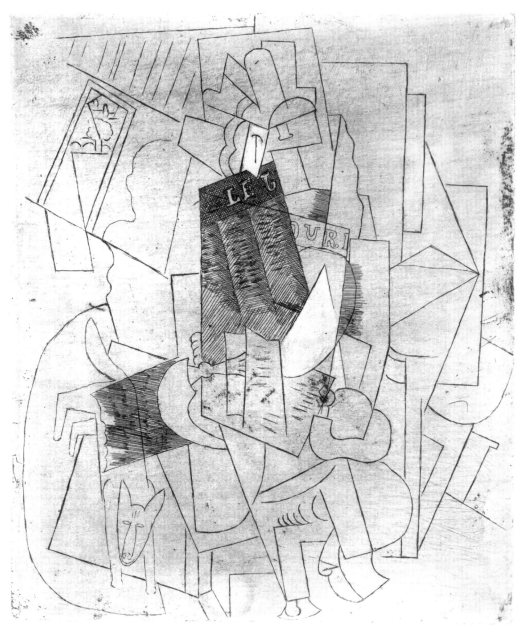

42. PICASSO

Etching, 1914

PABLO PICASSO
1881-1973

43. Cliché Kahnweiler, 1914

Engraving on halftone printing plate
110 x 100 mm.; 4⁵/₁₆ x 3¹⁵/₁₆ inches
Annotated on verso, "tiré par Fort" and bearing, on verso, the purple, oval stamp of the Succ(ession) Pablo Picasso Coll(ection) Marina Picasso.

Provenance:
1. Pablo Picasso (estate)
2. Marina Picasso
3. Sanford Weiss

Reference:
Geiser 40-VII/VII

Exhibited:
Cubist Prints/Cubist Books, Donna Stein, Franklin Furnace, New York, 1983, No. 23, illustrated on p. 39 and on cover.

Notes:
In this work, Picasso re-worked a negative of another of his Cubist works in the collection of D.H. Kahnweiler. Printed by Picasso's printer Fort, this appears to be one of only four impressions of this rare, final state.

43. PICASSO Engraving on half-tone printing plate (actual size),
 1914.

PABLO PICASSO
1881-1973

44. L'Homme à la Guitare (trial proof), 1915

Engraving
153 x 115 mm.; 6 x 4^1/$_2$ inches

Provenance:
Marina Picasso (stamp on verso)

References:
1. Geiser 51
2. Bloch 30

Notes:
This appears to be a rare proof impression on *japan ancien* paper, aside from the signed and numbered edition of 100, printed by Leblanc and Trautmann in 1929.

44. PICASSO

Engraving (trial proof), 1915

JACQUES VILLON
1875-1963

45. L'Aide gracieuse, 1907

Etching: edition of 30
197 x 147 mm.; 8 x 5¾ inches
Signed and numbered 29/30

References:
1. Auberty & Perussaux 117
2. Ginestet & Pouillon E. 202

Notes:
This etching and the two following are fine examples of a group of prints produced by Villon in 1907. These works may be some of the earliest known Cubist experiments by any artist in any medium. Braque's *Etude de nu* etching, no. 1 in this catalogue, is usually dated 1907-1908 and is therefore the only other Cubist print possibly executed as early as Villon's 1907 graphic works. Interestingly, however, Villon had not yet established contact with either Braque or Picasso in 1907. Thus, Villon, in this series of prints, would appear to have produced some of the first cubist-orientated works independently of either Braque or Picasso.

JACQUES VILLON
1875-1963

46. Trois femmes sur l'herbe, 1907

Etching
169 x 246 mm.; 7 x 9⅞ inches
Signed and annotated: "épreuve tirée au chiffon mouillé"

References:
1. Auberty & Perussaux 118
2. Ginestet & Pouillon E. 203

JACQUES VILLON
1875-1963

47. Les femmes de Thrace, 1907

Etching
218 x 168 mm.; 8½ x 7 inches
Signed and annotated: "ep d'artiste"

References:
1. Auberty & Perussaux 119
2. Ginestet & Pouillon E. 205

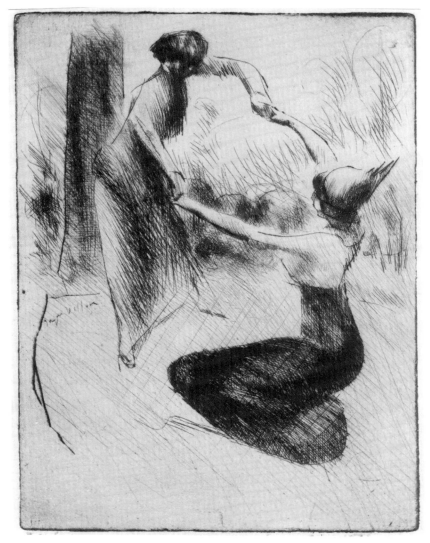

45. VILLON Etching, 1907

JACQUES VILLON
1875-1963

48. Nu debout, bras en l'air, 1909

Etching and drypoint: edition of 23
550 x 415 mm.; $21^5/_8$ x $16^{11}/_{16}$ inches
Signed and numbered 1/23

References:
1. Auberty & Perussaux 163
2. Ginestet & Pouillon E.245

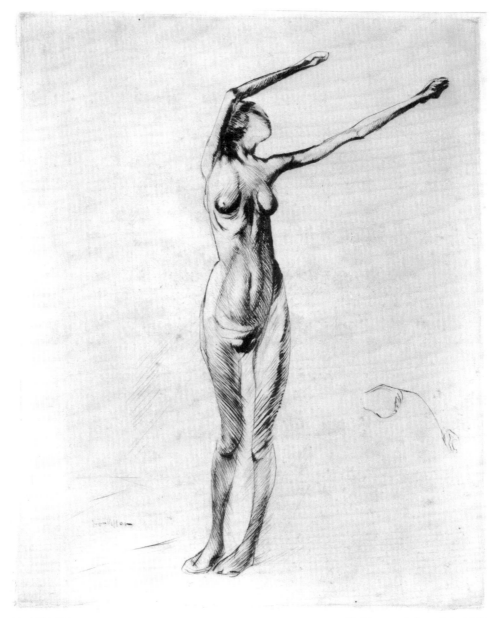

48. VILLON Etching and drypoint, 1909

JACQUES VILLON
1875-1963

49. Femme debout, de dos (nue), 1909-1910

Etching and drypoint: edition of 15
318 x 193 mm.; 12^1/$_2$ x 7^5/$_8$ inches
Signed and numbered

References:
1. Auberty & Perussaux 166
2. Ginestet & Pouillon E.248

Exhibited:
Jacques Villon, Fogg Art Museum, Cambridge, Massachusetts, 1976, No. 24 and reproduced on page 47.

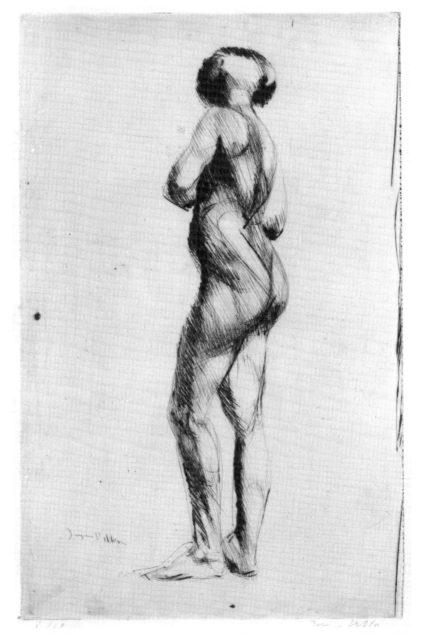

49. VILLON Etching and drypoint, 1909-1910

JACQUES VILLON
1875-1963

50. Bal du Moulin Rouge (2nd State), 1910

Etching with pen and ink
392 x 300 mm.; 15³/₈ x 11³/₄ inches
Signed and annotated by artist: "tiré à deux épreuves - No. 1 - épreuve nature"

References:
1. Auberty & Perussaux 172-I/III
2. Ginestet & Pouillon E.249-II/IV

Notes:
There appear to be only three known impressions of this work before the plate was cut down to about half its size. There is the one very sketchy impression of Ginestet & Pouillon's 1st State at the Bibliothèque Nationale in Paris. There are only two known impressions of Ginestet & Pouillon's 2nd State. This is one and another is at the Art Institute of Chicago. The 3rd State was printed after the plate was cut and shows only the lower half of the plate. There are only two known impressions of the 3rd State, one of which belongs to the same collection as the present work.

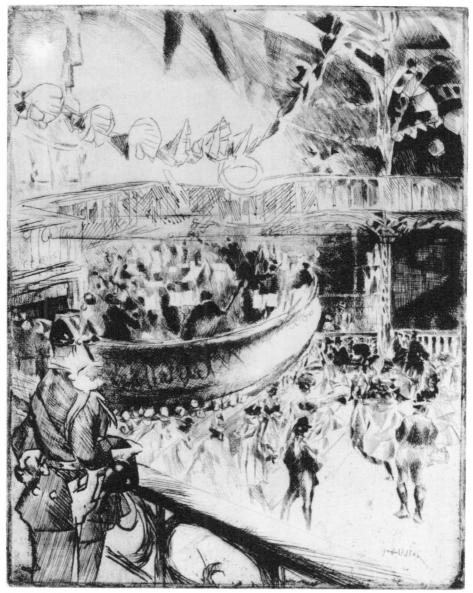

50. VILLON Etching with pen and ink, 1910

125

JACQUES VILLON
1875-1963

51. Musiciens chez le Bistro (trial proof of final state), 1912

Etching
271 x 237 mm.; 10$^1/_2$ x 9$^1/_8$ inches
Signed and annotated "etat definitif"

References:
1. Auberty & Perussaux 185
2. Ginestet & Pouillon E.270-V/V

Notes:
1. A rare, perhaps unique, richly inked trial proof of the final state, printed on a heavy, wove paper very different from the lighter paper used for the normal edition of fifty impressions.
2. This is a key work in Villon's graphic oeuvre. At this time, probably early in 1912 before Villon had read about the Golden Section in Leonardo da Vinci's *Trattato della Pittura*, an artist could have either returned to some form of post-Impressionism or moved in the direction of "Cubism". Villon has chosen a very post-Impressionist type of subject in this work at the same time that his treatment of the subject is quite "Cubist". Later in 1912, Villon would move increasingly away from post-Impressionism.

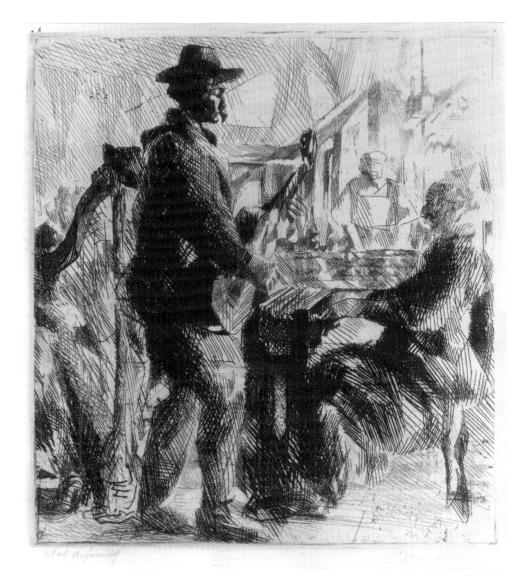

51. VILLON Etching (trial proof), 1912

JACQUES VILLON
1875-1963

52. Les Soldats qui marchent, about 1912

Watercolor
160 x 223 mm.; 6^{1}/$_{4}$ x 8^{3}/$_{4}$ inches
Signed, upper left

Notes:
This important watercolor is quite closely related to the photograph of a drawing which Villon reworked in wash, *Les Soldats qui marchent*, 1912, which belongs to the Musée National d'Art Moderne in Paris and which was no. 146 and reproduced on page 25 of: *Jacques Villon: Master of Graphic Art*, Museum of Fine Arts, Boston, 1964. Both of these works are related to *Les Soldats qui marchent* painting, 1912, which also belongs to the Musée National d'Art Moderne in Paris.

52. VILLON Watercolor, about 1912

JACQUES VILLON
1875-1963

53. Portrait de E.D., 1913

Drypoint
235 x 160 mm.; 9$^{1}/_{4}$ x 6$^{1}/_{4}$ inches
Signed and numbered

References:
1. Auberty & Perussaux 191
2. Ginestet & Pouillon E.277

Notes:
1. This is a portrait of the artist's father, Eugene Duchamp. It is related to two oil portraits of Villon's father, one dated 1912 in the Rouen Museum and the other dated 1913 and reproduced on page 22 of this book. This drypoint also could be compared with another drypoint, *Monsieur D. lisant*, 1913 (no. 58 of this book). This latter work was executed later in 1913 and is considerably more abstract than this portrait.
2. Some impressions of this drypoint indicate an edition of 25, others an edition of 26.

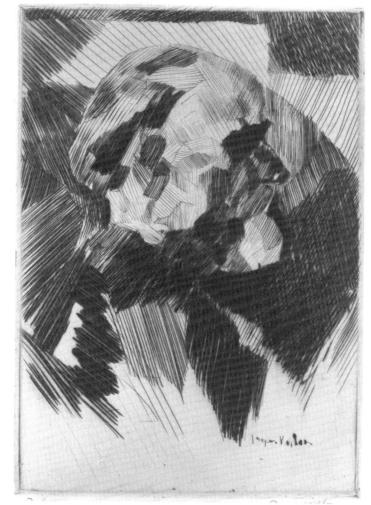

53. VILLON

Drypoint, 1913

JACQUES VILLON
1875-1963

54. Yvonne D. de profil (1st State, before steel-plating and before signature in plate), 1913

Drypoint
550 x 415 mm.; $21^5/8$ x $16^5/16$ inches
Signed, numbered 11/11 and annotated by Villon "1er Etat"

Provenance:
Madame Marcel Duchamp, Paris

References:
1. Auberty & Perussaux 194-I/II
2. Ginestet & Pouillon E. 280 - I/III
3. Reproduced on page 76 of: *Les 3 Duchamp* by Pierre Cabanne, Neuchatel, 1975.
4. No. 83 and reproduced on cover of: *Homage to Jacques Villon*, R.S. Johnson Fine Art, Chicago, Winter 1975-1976.

Notes:
1. One of two known impressions of this extremely important work before steel-facing and before the drypointed signature was added to the plate. There are apparently nine other impressions before steel-facing but with the drypointed signature added to the plate made by Villon. After steel-facing, this work was printed in twenty-three numbered impressions. This superb and one of two earliest known impressions of this work is extraordinarily rich in burr, the effects of the fresh drypoint extremely evident.
2. This is the portrait of Yvonne Duchamp, the sister of the brothers Marcel Duchamp, Raymond Duchamp-Villon and Jacques Villon.
3. We know of the whereabouts of seven of the eleven impressions of this work before steel-plating. These are:

No. 3/11 Signed, numbered 3/11 and annotated by Villon "1er Etat". Boston Public Library (No.52 and reproduced on page 47 of *Jacques Villon: Master of Graphic Art*, Museum of Fine Arts, Boston, 1964).

No. 4/11 Signed, numbered 4/11 and annotated by Villon "1er Etat". Rijksmuseum Amsterdam (No. 61 and reproduced on page 67 of: *Jacques Villon: Grafiek Uit een particuliere verzamling*, Rijksmuseum, Amsterdam, 1984). This impression, presently in the collection of Mr. and Mrs. Van der Vossen-Delbruck, is understood to be a promised gift to the Rijksmuseum.

No. 7/11 Signed, numbered 7/11 and annotated by Villon "1er Etat". This work was reproduced as No. 180 of: *Master Prints of Five Centuries* (The Alan and Marianne Schwartz Collection), The Detroit Institute of Art, October-November, 1990.

No. 8/11 Signed, numbered 8/11 and annotated by Villon "1er Etat". Private Illinios Collection.

No. 9/11 Signed, numbered 9/11 and annotated by Villon "1er Etat". This impression was reproduced as No. 8 of: *Master Graphics 1890-1980*, R. S. Johnson Fine Art, Chicago, Fall, 1989. Presently: Private Collection, Dallas, Texas.

No. 10/11 Numbered 10/11 and annotated by Villon "1er Etat". However, different from all the above impressions, this one is not only before steel-facing but also before the addition of the drypointed signature in the plate. Collection of The National Gallery, Washington D.C.

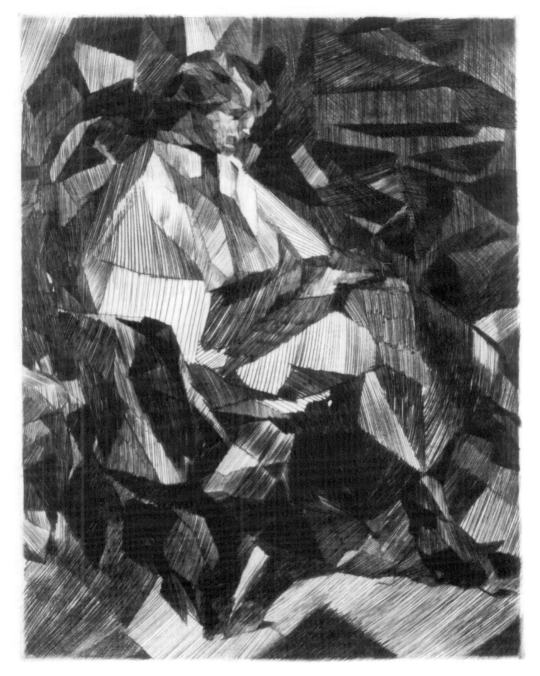

54. VILLON Drypoint (1st State before signature in plate), 1913

No. 11/11 The impression reproduced in this catalogue. Signed, numbered 11/11 and annotated by Villion "1er Etat". Like the 10/11 impression described above (The National Gallery, Washington D.C.), this impression, unlike the impressions numbered from 9/11 to 1/11, is not only before steel-facing, but also before the drypointed signature was added to the plate.

4. Auberty & Perussaux, in their Villon catalogue of 1950 (*Jacques Villon: Catalogue de son Oeuvre Gravé*, Paris, 1950) distinguish between eleven impressions of this work in the 1st State and twenty-three impressions of the 2nd State. Ginestet & Pouillon, in their Villon catalogue of 1979 (*Jacques Villon, Les Estampes et les Illustrations*, Catalogue Raisonné, Paris, 1979) distinguish three states: 1st State before the drypointed signature in the plate ("a few proofs"); 2nd State of eleven numbered impressions with the drypointed signature in the plate; and the 3rd State edition of twenty-three impressions. The above cataloguing should be corrected to:

1st State Before steel-plating and before the drypointed signature in plate: two known impressions numbered 10/11 and 11/11, one at the National Gallery of Washington D.C. and the other in this catalogue.

2nd State Before steel-plating but with the drypointed signature in the plate: nine (rather than eleven) impressions numbered 1/11 to 9/11.

3rd State The edition of apparently twenty-three impressions.

The cataloguing confusion to date on this work has resulted from the fact that Villon obviously numbered the first eleven impressions in the reverse order of their printing. The clearly earliest two impressions, both before the drypointed signature, are numbered 11/11 and 10/11 while the nine impressions which followed were numbered 9/11 to 1/11. After printing, Villon simply began numbering the proof on the top of the pile, the last one of the eleven printed.

JACQUES VILLON
1875-1963

55. Yvonne de face, (Trial proof before steel-facing), 1913

Drypoint: edition of 28
550 x 415 mm.; 21^5/$_8$ x 16^5/$_{16}$ inches
Signed and annotated "tiré à 28 ép."

References:
1. Auberty & Perussaux 195
2. Ginestet & Pouillon E. 281

Note:
A superb impression before steel-facing and very rich in burr.

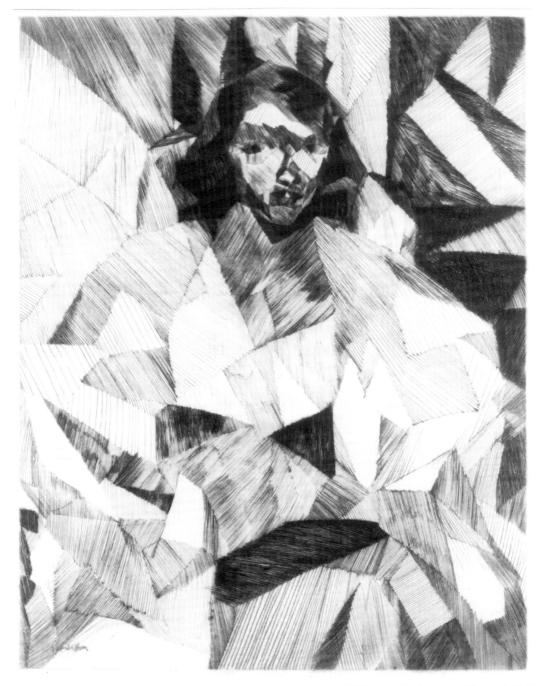

55. VILLON Drypoint, (Trial proof before steel-facing) 1913

JACQUES VILLON
1875-1963

56. Portrait de jeune Femme, 1913

Drypoint
550 x 415 mm.; 21$\frac{1}{2}$ x 16$\frac{3}{16}$ inches
Signed, numbered 6/25 and dedicated: "à Perussaux-ce portrait de Suzanne Duchamp"

References:
1. Auberty & Perussaux 193
2. Ginestet & Pouillon E.282

Notes:
1. Villon indicates different size editions on different proofs. Thus, the full edition may be 25, 26, 30 or 32 impressions.
2. Charles Perussaux, to whom this impression was dedicated, was the co-author, with J. Auberty, of *Jacques Villon, catalogue de son oeuvre gravé*, Paris, 1950.

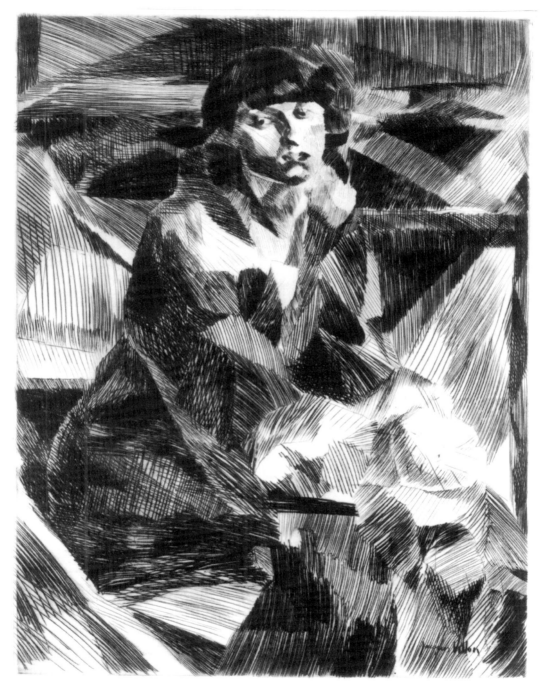

56. VILLON

Drypoint, 1913

JACQUES VILLON
1874-1963

57. **Portrait d'acteur (Félix Barré)**, (trial proof), 1913

Drypoint
400 x 315 mm.; 15³/₄ x 12³/₈ inches
Signed and annotated "essai"

Provenance:
Madame Marcel Duchamp, Paris

References:
1. Auberty & Perussaux 199
2. Ginestet & Pouillon E.183
3. Reproduced on p. 79 of: *Les 3 Duchamp* by Pierre Cabanne, Neuchatel, 1975.

Notes:
A superb, rare and perhaps unique impression before Villon drypointed his signature in the plate.

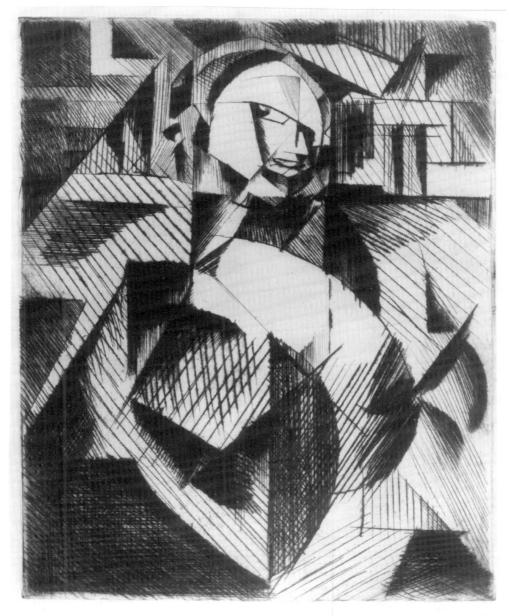

57. VILLON Drypoint (trial proof before signature in plate), 1913

JACQUES VILLON
1875-1963

58. Monsieur D. lisant (trial proof), 1913

Drypoint
390 x 295 mm.; 15^3/$_4$ x 11^1/$_4$ inches
Signed and annotated "essai"

References:
1. Auberty & Perussaux 198
2. Ginestet & Pouillon E.284

Notes:
1. A superb trial proof before the edition of 32.
2. This portrait is of Monsieur Duchamp, the father of the artist (who also was the father of Marcel Duchamp and of Raymond Duchamp-Villon). This drypoint is considerably more abstract than the drypoint *Portrait de E.D.* (no. 53 of this book) executed earlier in 1913.

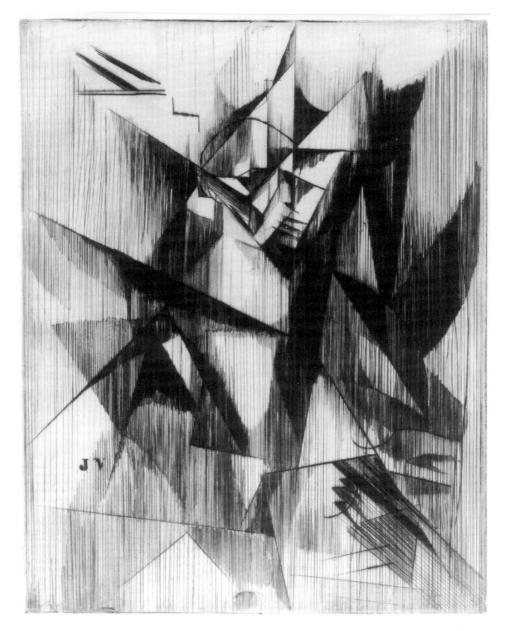

58. VILLON Drypoint (trial proof), 1913

JACQUES VILLON
1875-1963

59. La Table Servie (1st State before steel-facing), 1913

Drypoint
285 x 385 mm.; 11³/₁₆ x 15³/₁₆ inches
Signed and numbered 1/30

References:
1. Auberty & Perussaux 196
2. Ginestet & Pouillon E.285

Exhibited:
Jacques Villon : Master of Graphic Art, Museum of Fine Arts, Boston, 1964, No. 54.

Notes:
1. There is an enormous difference between the 1st and 2nd States of this work, the rich burr having been completely removed for the 2nd State. The 1st and 2nd States have been indicated by all catalogues to date as being of 30 impressions each. However, the highest numbered impression of the 1st State which we have encountered is numbered 7/30. In addition, there appear to be a few other impressions with the usual "tiré à 30", typical of the 2nd State, after steel-facing, but which actually are also before steel-facing. One of these is in the collection of Roland Pressat (No. 47 of: *Jacques Villon: L'Oeuvre Gravé*, Musée du Dessin et de l'Estampe Originale, Gravelines June-September 1989). Another, which now is in a Japanese museum, was reproduced in: *Master Graphics: 1890-1980*, R.S. Johnson Fine Art, Chicago, Fall, 1989, no. 9, pp. 22-23. Thus, there do not appear to be more than about ten impressions of this work before steel-facing, the numbered edition before steel-facing apparently stopping at 7/30.
2. The following 1st State impressions are the only numbered ones known to us:
 a. This impression: 1/30
 b. St. Louis Art Museum: 3/30
 c. Art Institute of Chicago: 6/30
 d. Bibliothèque Nationale, Paris (ref. Kornfeld no. 475, 1986): 7/30

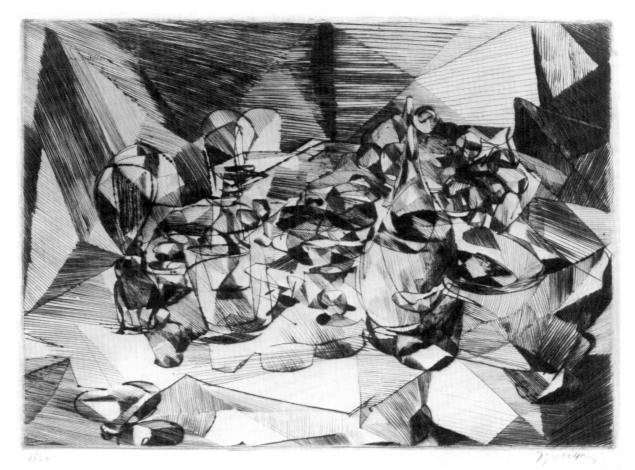

1/30 Jquillon

59. VILLON Drypoint (1st State before steel-facing), 1913

JACQUES VILLON
1875-1963

60. L'Equilibriste, 1913

Drypoint: edition of 28
400 x 300 mm.; 16 x 11³/₄ inches
Signed

References:
1. Auberty & Perussaux 197
2. Ginestet & Pouillon E.286

Notes:
1. This is the most abstract of Villon's magnificent series of drypoints from 1913. It points forward to Villon's two equally abstract etchings from 1914: (cat. nos. 61, 62).
2. This drypoint corresponds to a painting, *L'Equilibriste,* 1913 (see below).

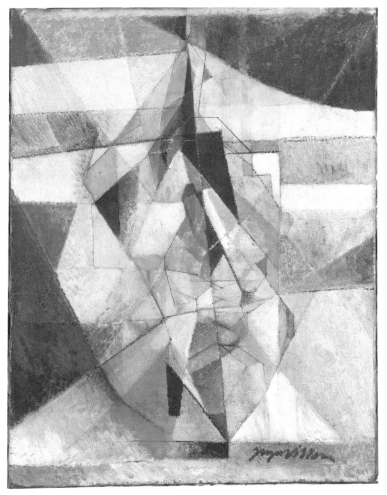

Fig. 7 JACQUES VILLON *L'Equilibriste* (High-wire Balancer), 1913
Oil on canvas, 31¹/₂ x 23¹/₂ in. This work was included in the exhibit of
Duchamp-Villon, Gleizes, Metzinger and Villon at the Sturm Galerie in
Berlin in 1914.

60. VILLON Drypoint, 1913

JACQUES VILLON
1875-1963

61. Le Petit Equilibriste, 1914

Etching: edition of 50
220 x 162 mm.; $8^5/_8$ x $6^7/_{16}$ inches
Signed and annotated by the artist

References:
1. Auberty & Perussaux 201
2. Ginestet & Pouillon E.287

Notes:
This work was re-published (in a clearly weaker and later impression) in: Lassaigne, *Éloge de Jacques Villon*, Editions Bruker, Paris, 1955.

61. VILLON Etching, 1914

JACQUES VILLON
1875-1963

62. Le Petit Atelier de Mécanique, 1914

Etching: edition of 50
162 x 220 mm.; 6$\frac{1}{8}$ x 7$\frac{9}{16}$ inches
Signed and annotated by the artist

References:
1. Auberty & Perussaux 202
2. Ginestet & Pouillon E.289

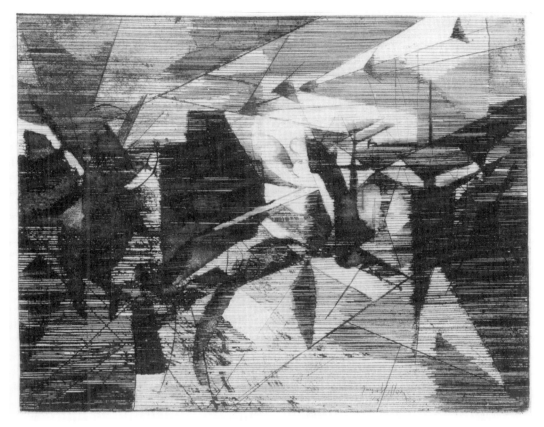

62. VILLON Etching, 1914

JACQUES VILLON
1875-1963

63. La Table d'échecs (early state), 1920

Etching
200 x 160 mm; 7^7/$_8$ x 6^1/$_4$ inches
Signed and annotated "Etat"

Provenance:
Louis Carré, Paris

References:
1. Auberty & Perussaux 203
2. Ginestet & Pouillon E.292

Exhibited:
Jacques Villon: Oeuvre Gravé, Louis Carré, Paris, 1954, No. 32 and reproduced on the cover.

Notes:
1. A very rare, early, trial proof, perhaps unique in this form, before numerous changes in the image.
2. *Table d'échecs* is the first plate etched by Villon after World War I. A key element in the development of the artist's graphic production, this particular etching was executed for the German publication *Die Schaffenden* which was issued in an edition of 125. Perhaps more than any other work, *Table d'echecs* sums up Villon's Cubist past (and in fact the whole movement of the *Section d'Or*) and points forward to the artist's post-Cubist future.

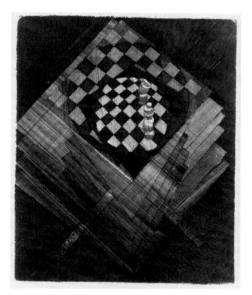

Fig. 8 JACQUES VILLON
La Table d'echecs, Etching (final state), 1920

150

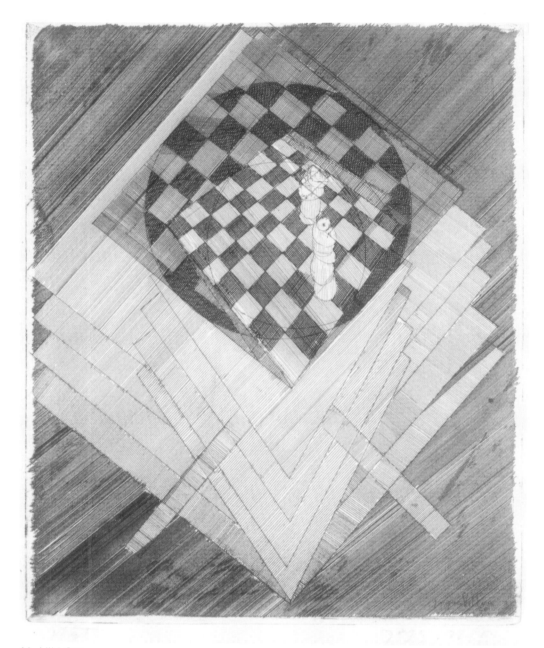

63. VILLON Etching (early state), 1920

ORIGINAL EDITIONS OF BOOKS ON CUBISM

64. GLEIZES, Albert and METZINGER, Jean

Du "Cubisme", Paris, November, 1912. Original edition. With personal dedication by the authors: "à Georges Normandy - très cordial hommage - Albert Gleizes - J. Metzinger" and with the address written below : "24 av. Gambetta - Courbevois".
Note:
This book was published on October 20, 1912 as part of a series of publications called *Collection Tous les Arts.* The cover indicates "Deuxième Edition" but there apparently never was a "1st Edition". This was an attempt to pre-date Apollinaire's book *Les Peintres Cubistes* which actually did not appear until March of 1913 though Apollinaire had presented his ideas in various lectures well before that date.

65. APOLLINAIRE, Guillaume

Les Peintres Cubistes, Paris, March, 1913. Original edition.
Note:
This book was published on March 17, 1913 as part of a series of publications called *Collection Tous les Arts.* Together with *Du "Cubisme"* by Gleizes and Metzinger, this is one of the two most important early books attempting to describe and define the early Cubist movement. Most of the material in this book had been published earlier in 1912 in a series of articles written by Apollinaire for *Les Soirées de Paris.* Apollinaire's book already was in proof form by October 11, 1912, at the time of the opening of *La Section d'Or* exhibition.

66. KAHNWEILER, Daniel Henry

Der Weg zum Kubismus, Delphin-Verlag, Munich, 1920. Original edition.
Note:
This book was published by Kahnweiler under his first and middle names, Daniel Henry, just after World War I.

67. JANNEAU, Guillaume

L'Art Cubiste, Editions d'Art Charles Moreau, Paris, 1929.
Original edition, numbered 387.
With dedication:
"à mon vieil ami Louis Vauxcelles - affectueux hommage de Guillaume Janneau"
(to my old friend Louis Vauxcelles, with fond hommage, from Guillaume Janneau).
Note:
Louis Vauxcelles, to whom this volume was personally dedicated, appears to be the art critic of the Cubist period who originated the term "Cubism". Vauxcelles had already referred to "cubes" in his review (*Gil Blas*, Paris, November 14, 1908) of the Georges Braque exhibit at the Kahnweiler gallery in November, 1908. In 1909, again in *Gil Blas* (May 25, 1909), Vauxcelles referred to the Braque paintings exhibited at the *Salon des Independants* as "bizarreries cubiques".

DER WEG
ZUM KUBISMUS

VON

DANIEL HENRY

MIT 47 ZINKATZUNGEN UND 6 GRAVÜREN

MÜNCHEN
DELPHIN-VERLAG

66. KAHNWEILER *Der Weg zum Kubismus,*
1920

GUILLAUME JANNEAU

L'ART CUBISTE

THÉORIES ET RÉALISATIONS

ÉTUDE CRITIQUE

ÉDITIONS D'ART CHARLES MOREAU
8, RUE DE PRAGUE, PARIS

67. JANNEAU *L'Art Cubiste,* 1929

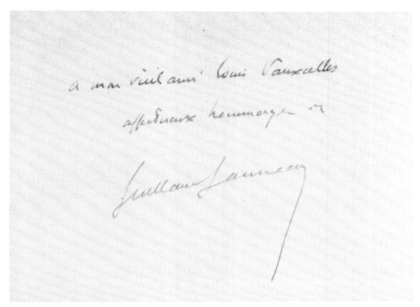

67. JANNEAU Dedication to Louis Vauxelles, who invented the term "Cubism".

SELECTED BIBLIOGRAPHY

Adhemar, Jean	*L'Oeuvre gravé de Derain*, Bibliothèque Nationale, Paris, 1955.
Apollinaire, Guillaume	*Meditations Esthétiques: Les Peintres Cubistes*, Figuiere et Cie, publishers, Paris, 1913.
	Chroniques d'art: 1902-1918, Gallimard, publisher, Paris, 1960.
Assouline, Pierre	*L'Homme de l'Art: D.H. Kahnweiler (1884-1979)*, Paris, 1988.
Auberty, Jacqueline and Perussaux, Charles	*Jacques Villon: Catalogue de son oeuvre gravé*, Paris, 1950.
Barr, Alfred H.	*Cubism and Abstract Art*, The Museum of Modern Art, New York, 1936.
Bloch, Georges	*Pablo Picasso: Catalogue de l'oeuvre gravé et lithographié 1904-1967*, Bern, 1968.
Bruhl, Georg	*Herwarth Walden und "Der Sturm"*, Dumont Verlag, Cologne, 1983.
Buckberrough, Sherry A.	*Robert Delaunay: The Discovery of Simultaneity*, University of Michigan Research Press, Ann Arbor, 1982.
Cabanne, Pierre	*L'Epopée du Cubisme*, Paris, 1963.
	Les 3 Duchamp, Ides et Calendes, Neuchatel, 1975.
Camfield, William A.	*Juan Gris and the Golden Section* in *Art Bulletin*, Vol. 47, No. 1 of March, 1965.
Cooper, Douglas	*The Cubist Epoch*, Los Angeles County Museum and The Metropolitan Museum of Art of New York, 1970.
Cooper, Douglas and Tinterow, Gary	*The Essential Cubism: 1907-1920, The Tate Gallery, London, 1983.*
Engelberts, Edwin	*Georges Braque: Oeuvre Graphique Originale*, Geneva, 1958.
Fry, Edward F.	*Cubism*, Thames and Hudson, London, 1966 (reprinted in 1978).
Gamwell, Lynn	*Cubist Criticism*, University of Michigan Research Press, Ann Arbor, 1980.
Geiser, Bernhard	*Picasso Peintre-Graveur: Catalogue illustré de l'oeuvre gravé et lithographié 1899-1931*, 2 vols., Bern, 1955-1968.
Ginestet, Colette and Pouillon, Catherine	*Jacques Villon, Les Estampes et les Illustrations, Catalogue Raisonné*, Paris, 1979.
Gleizes, Albert and Metzinger, Jean	*Du "Cubisme"*, Figuiere et Cie, publishers, Paris, 1912.
Golding, John	*Cubism: A History and an Analysis 1907-1914*, Faber and Faber, London, 1959.
Goldwater, Robert	*Primitivism in Modern Art*, Harvard University Press, Cambridge and London, 1986 (enlarged edition).
Green, Christopher	*Léger and the Avant-Garde*, Yale University Press, New Haven and London, 1976.
	Cubism and Its Enemies, Yale University Press, New Haven and London, 1987.
Grey, Christopher	*Cubist Aesthetic Theories*, Baltimore, 1953.

Henderson, Linda Dalrymple	*The Fourth Dimension and Non-Euclidean Geometry in Modern Art*, Princeton University Press, 1983.
Janneau, Guillaume	*L'Art Cubiste*, Charles Moreau, Paris, 1929.
Johnson, R. Stanley	*Metzinger: Pre-Cubist and Cubist Works 1900-1930*, R.S. Johnson Fine Art, Chicago, 1964.
	Fernand Léger: Retrospective Exhibition, R.S. Johnson Fine Art, Chicago, 1966.
	Jacques Villon: Master of Graphic Art, R.S. Johnson Fine Art, Chicago, 1967.
	Homage to Jacques Villon: A Retrospective Exhibition, R.S. Johnson Fine Art, Chicago, 1975-1976.
	Homage to Picasso: Drawings, Watercolors and Pastels 1900-1972, R.S. Johnson Fine Art, Chicago, 1973.
	Pablo Picasso: Master of Graphic Art, R.S. Johnson Fine Art, Chicago, 1984.
	Cubism & La Section d'Or: Works on Paper 1907-1922, R.S. Johnson Fine Art, Chicago, Fall, 1989.
Kahnweiler, Daniel-Henry	*Der Weg zum Cubismus*, Delphin-Verlag, Munich, 1920 (name of author indicated only as: Daniel Henry).
	Juan Gris: sa vie, son oeuvre, ses écrits, Gallimard, Paris, 1946.
Lafranchis, Jean	*Marcoussis: sa vie, son oeuvre, Catalogue complet des peintures, fixes sur verre, aquarelles, dessins, gravures*, Paris, 1961.
Loyer, Jacqueline	"L'Oeuvre Gravé de Albert Gleizes", *Nouvelles de l'Estampe*, No. 26, March-April, 1976.
Loyer, Jacqueline and Perussaux, Charles	"Catalogue de l'oeuvre lithographique de Robert Delaunay", *Nouvelles de l'Estampe*, No. 15, May-June, 1974.
Metzinger, Fritz (et al)	*Die Entstehung des Kubismus*, Fischer Verlag, Frankfurt, 1990.
Metzinger, Jean	See: Gleizes
Moser, Joann	*Jean Metzinger in Retrospect*, The University of Iowa Museum of Art, Iowa City, 1985.
Robbins, Daniel	*Albert Gleizes*, Guggenheim Museum, New York, 1964.
Rosenblum, Robert	*Cubism and Twentieth Century Art*, Harry N. Abrams, New York, 1961.
Sawyer, David	*Prints by André Derain*, Newport News, Virginia, 1988.
Seligman, Germain	*Roger de La Fresnaye*, Ides et Calendes, Neuchatel, 1969.
Stein, Donna	*Cubist Prints: Cubist Books*, Franklin Furnace, New York, 1983.
Vallier, Dora	*Jacques Villon*, Musée des Beaux-Arts, Rouen and Grand Palais, Paris, 1975.
	Braque, l'Oeuvre Gravé, Catalogue raisonné, Lausanne, 1982.
Wallen, Burr and Stein, Donna	*The Cubist Print*, University of California, Santa Barbara, 1981.
Warnod, Jeanine	*Le Bateau-Lavoir*, Les Presses de la Connaissance, Paris, 1975.
West, Richard V.	*Painters of the Section d'Or: The Alternative to Cubism*, Albright-Knox Gallery, Buffalo, 1967.

BIOGRAPHIC NOTES

GEORGES BRAQUE (1882-1963)

Born in 1882 in Argenteuil, in the region of l'Ile-de-France. His father was a house painter but also a "Sunday painter". Braque exhibited six "Fauve" paintings in the Independants exhibit in 1906. In 1907, he met the dealer Kahnweiler who became his agent. Then he met Picasso and saw his famous painting *Les Demoiselles d'Avignon*. His Cubist works, along with those of Picasso, were revolutionary for their time. In his post-Cubist decades, Braque produced a rather calm type of painting which associated him with the past traditions of French art.

ROBERT DELAUNAY (1885-1941)

Born in 1885 in Paris, Delaunay in his earlier work was particularly influenced by Cézanne. He found his own artistic path around 1910 with his depiction of cities and towers. Later, with his abstract circular forms, Delaunay departed from his brief relationship with Cubism. Apollinaire gave his art the title of "orphique", thus setting him aside from the other Cubists. After his participation in the *Blaue Reiter* exhibit in Munich in 1911 and in the Sturm Galerie exhibit in Berlin in 1913, Delaunay's influence was particularly strong in Germany.

ANDRÉ DERAIN (1880-1954)

Born in 1880 in Chatou, just outside of Paris, Derain met Matisse in 1898 and then Vlaminck who also lived at Chatou. In 1905, Derain became one of the major "Fauves" along with Braque, Matisse and Vlaminck. By 1908, however, Derain was influenced by Cézanne and began his brief move towards Cubism. By 1920, Derain abandoned his previous associations with the Fauves and then the Cubists and turned towards a more classical form of painting.

ALBERT GLEIZES (1881-1953)

Born in Paris in 1881, Gleizes early in his career associated himself with the group of artists who met in Jacques Villon's studio in Puteaux. He was a major participant in the *Section d'Or* exhibits. He also was an important writer having published his famous book *Du "Cubisme"* together with Jean Metzinger in 1912. By the 1920's Gleizes evolved an increasingly abstract idiom which often approached pure decoration in its conception and effect.

JUAN GRIS (1887-1927)

Born in Madrid in 1887 with the name of José Victoriano Gonzalez, he became known as Juan Gris. He went to Paris in 1906 and lived in the famous Bateau-Lavoir where Picasso and his friends also lived. Kahnweiler became his dealer, eventually his biographer and also presented him to Gertrude Stein and to the dealer Leonce Rosenberg. Although Gris was closely associated with Picasso, he executed a much more "scientific" painting which allied him with Jacques Villon and the other artists of the Puteaux group such as Metzinger and Gleizes.

ROBERT DE LA FRESNAYE
(1885-1925)

Born in 1885 in Mans in west-central France, La Fresnaye was in the Ecole des Beaux-Arts in Paris by 1903. In 1911, he adopted a rather "Cubist" type of painting but never was able to fully accept most of the Cubist theories. In 1920, La Fresnaye turned to a more "realist" type of art which marked the last years before his death in 1925.

FRENAND LÉGER (1881-1955)

Born in 1881 in Argentan in Normandy, Léger met Picasso and Braque in Paris in 1910. Léger participated with Metzinger, Gleizes and Delaunay in the various manifestations of the *Section d'Or*. His first personal exhibit was with the dealer Kahnweiler in 1912 and, perhaps because of his Kahnweiler relationship, Léger often has been placed together with Picasso and Braque. Over the decades, Léger evolved a very singular type of painting dominated by the theme of "modern man" and by the subject of "Man in the City". This basic direction of Léger already was present in his studies for *La Ville* from 1919 and 1920.

LOUIS MARCOUSSIS (1883-1941)

Born in Warsaw in 1883 with the name of Louis Markus, he arrived in Paris in 1901. In Paris he met Apollinaire who gave him the name of Marcoussis, the name of a village in l'Ile-de-France. Marcoussis was strongly influenced by Impressionism until about 1907 when he became interested in the Cubist "experiments". He participated in *La Section d'Or* exhibit in Paris in 1912. By the 1920's Marcoussis turned to a more abstract, and also more decorative, type of painting.

JEAN METZINGER (1883-1956)

Born in Nantes, in west-central France, Metzinger became interested in Cubism from about 1908 onwards. He participated in the "Cubist" manifestations of 1911 and then at the *Section d'Or* exhibit of 1912. In 1912, he published, with Gleizes, the book *Du "Cubisme"*. Metzinger, early on quite influenced by Juan Gris, continued to work in a Cubist idiom until the end of his life.

PABLO PICASSO (1881-1973)

Born in 1881 in Malaga in southern Spain, Picasso came to Paris in 1900. His first exhibit was at the gallery of Ambroise Vollard. In these early years in Paris, Picasso produced his Blue and Rose Period works. His famous *Les Demoiselles d'Avignon* of 1907 marked the beginnings of Cubist painting. It was around this time that he met Braque and Matisse as well as established a contract with the dealer Kahnweiler who would become an important theorist of Cubism. His period of close cooperation with Braque culminated in the Cubist works of the summer of 1911 at Ceret. By 1918-1919, Picasso abandoned his "Cubist" idiom and entered a new phase of "Realism" which marked his production of the 1920's and 1930's.

JACQUES VILLON (1881-1973)

Born in 1875 in Damville in Normandy with the name of Gaston Duchamp. In order to distinguish himself from his brothers, the artist Marcel Duchamp and the sculptor Raymond Duchamp-Villon and perhaps because of his appreciation of the poet Francois Villon, he changed his name to Jacques Villon. Early on, Villon did drawings for various publications such as *l'Assiette au beurre, le Chat noir* and *Le Rire*. He executed a magnificent series of color aquatints from 1899 to 1906. In 1907, Villon produced some of the earliest Cubist works in any medium, a series of etchings. These experiments culminated in his great Cubist drypoints of 1913. Villon's studio at Puteaux brought together artists interested in the theories of the *Section d'Or*. Villon, along with Juan Gris, was one of the few artists to make practical use of the *Section d'Or* and thereby developed a valid alternative to the Cubism of Picasso and Braque.